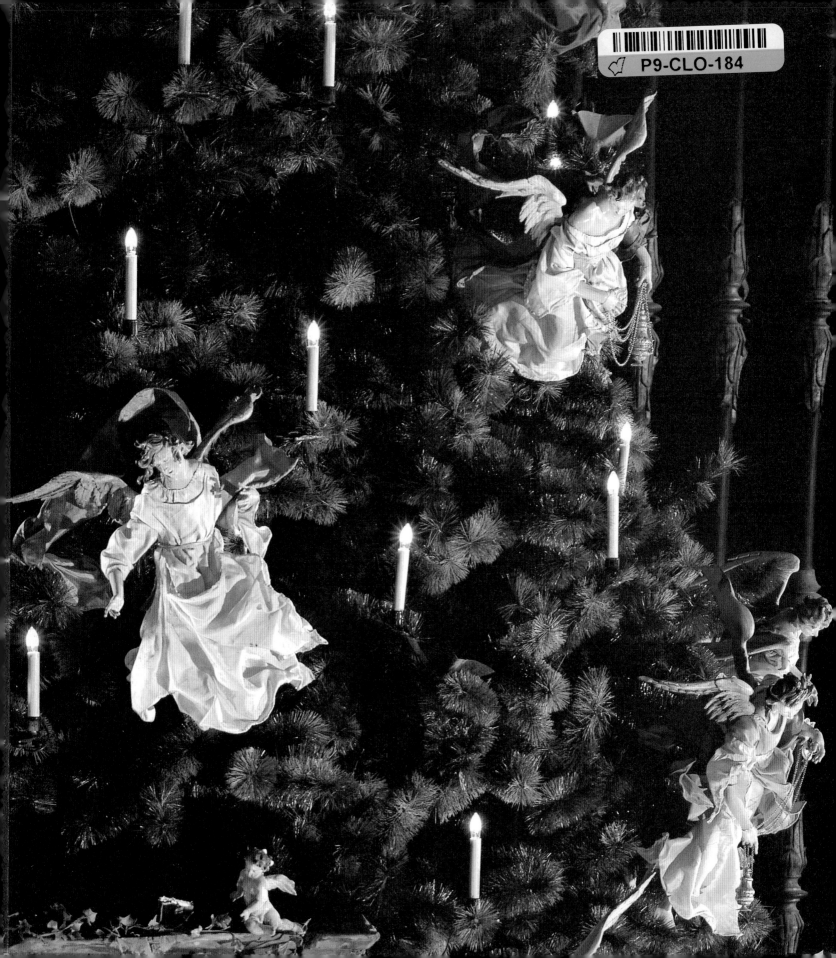

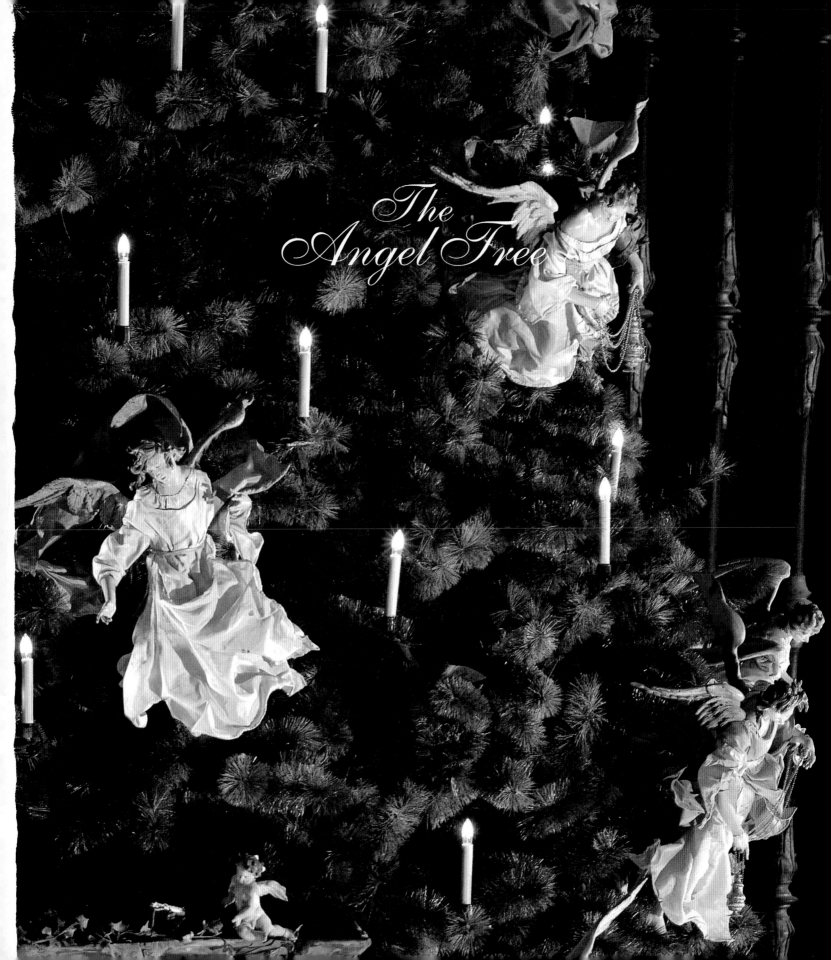

The Angel Tree

The Loretta Hines Howard Collection

of eighteenth-century Neapolitan crèche figures

at The Metropolitan Museum of Art

Linn Howard and Mary Jane Pool

Photographs by Elliott Erwitt

Harry N. Abrams, Inc., Publishers

The Angel Tree

A Christmas Celebration

Project Director: Margaret L. Kaplan

Designer: Carol A. Robson

All Biblical quotations are from The King James Version

The text in this book is partially based on *The Angel Tree*
published by Alfred A. Knopf in 1985

Library of Congress Cataloging-in-Publication Data

Howard, Linn

The angel tree: a Christmas celebration: the Loretta Hines
Howard collection of eighteenth-century Neapolitan crèche figures at
the Metropolitan Museum of Art/Linn Howard and Mary Jane Pool;
photographs by Elliott Erwitt.

p. cm.

Includes bibliographical references and index.

ISBN 0–8109–1934–6

1. Crèches (Nativity scenes)—Italy—Naples—History—18th
century. 2. Decorative arts—Italy—Naples—History—18th century.
3. Howard, Loretta Hines—Art collections. 4. Crèches (Nativity
scenes)—Private collections—New York (N.Y.) 5. Metropolitan
Museum of Art (New York, N.Y.) I. Pool, Mary Jane. II. Erwitt,
Elliott. III. Metropolitan Museum of Art (New York, N.Y.)
IV. Title. V. Title: Loretta Hines Howard collection.

NK1655.N36H68 1994

704.9'4853'0946730747471—dc20 93–25365

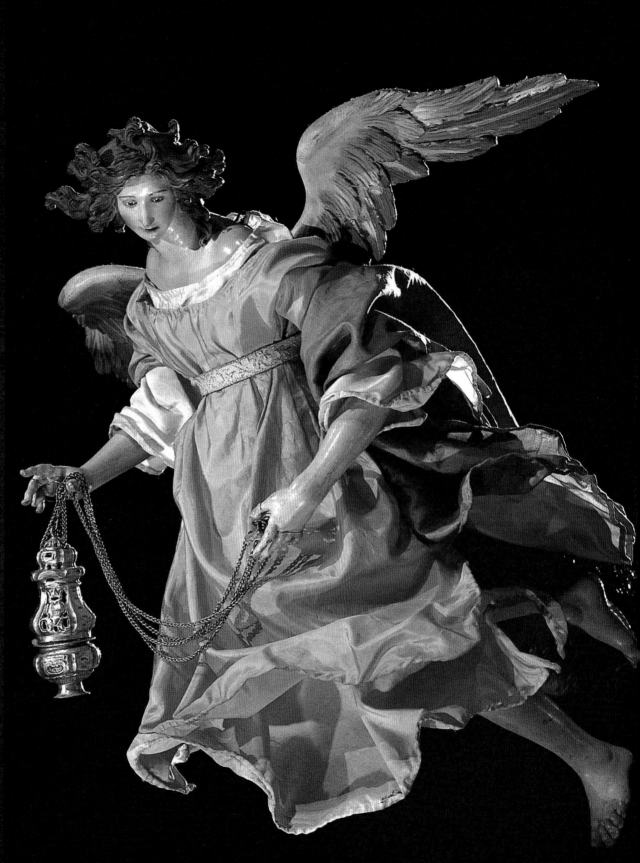

Table of Contents

For Loretta Hines Howard
who created the Angel Tree

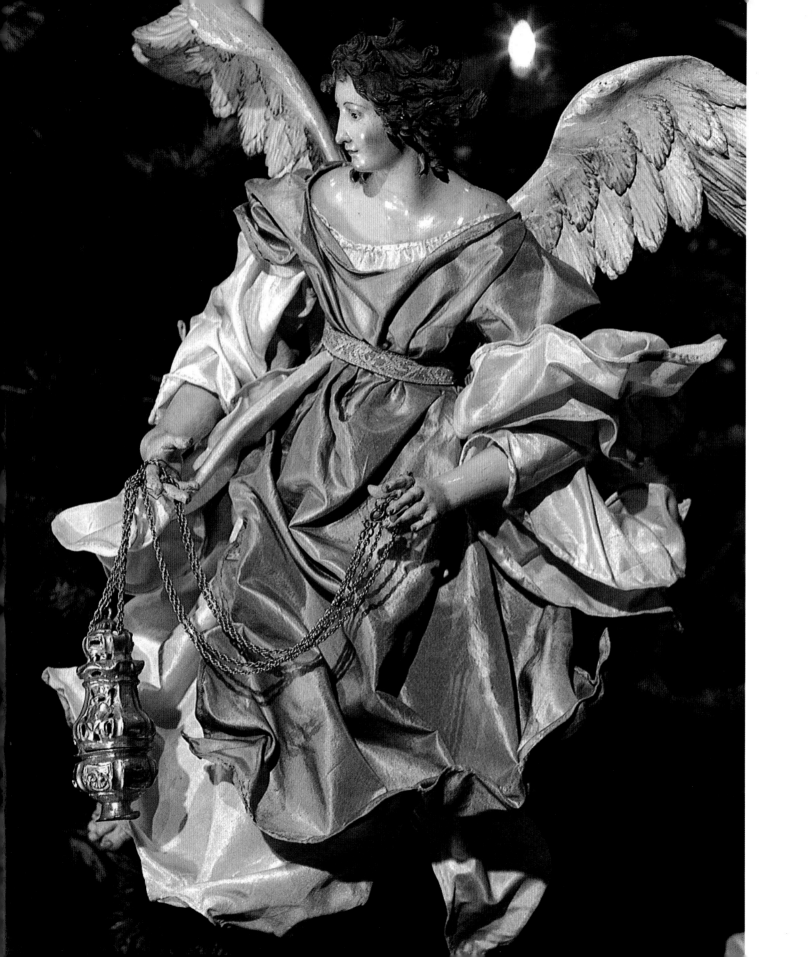

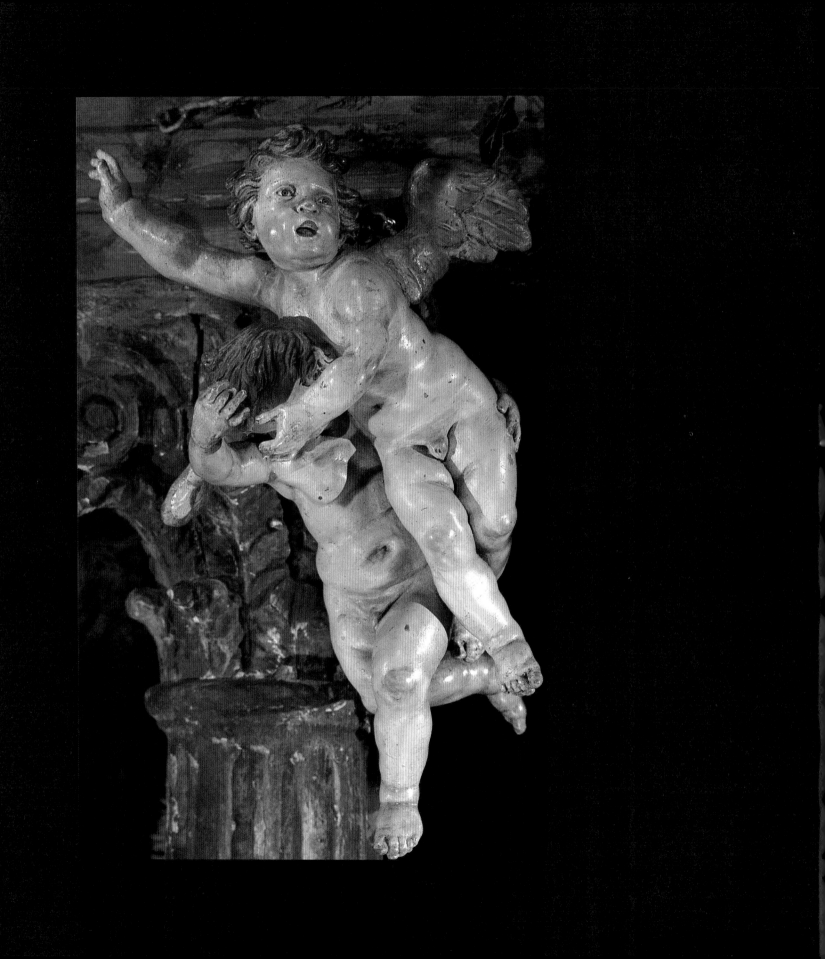

Foreword

For three decades, thanks to the generosity of Loretta Hines Howard, the annual installation of the Metropolitan Museum's Christmas tree has become a well-loved tradition in our Medieval Sculpture Hall. For those who enjoy the excitement of the Christmas season, the decoration and illumination of the tree is a cherished event. The sculptured base of the huge tree supports a charming landscape in which exquisite eighteenth-century Neapolitan figures reenact the events of Christ's Nativity. The three magi, dressed in sumptuous robes, are surrounded by their entourages, complete with lifelike beasts of burden. Travelers and townspeople throng to Bethlehem to view the diminutive figure of the Child lying peacefully on a nest of straw, flanked by the graceful figures of Mary and Joseph. Above them, angels hover, suspended from branches of the tree. One can only marvel at the masterful craftsmanship and the infinite care taken with each individual's face and gesture.

Most of the figures in the Loretta Hines Howard collection were once part of the famous Catello collection in Naples. We are indeed grateful to her for this splendid gift, which has given so much joy to Museum visitors through the years. It is a tribute to the beauty of the tree that its impact never diminishes as time goes by; the crèche never fails to cast a spell over visitors of all ages.

I should also like to thank Linn Howard, Loretta Hines Howard's daughter, for continuing the work of her mother and for giving so much of her time and care to the installation each year.

PHILIPPE DE MONTEBELLO
DIRECTOR, THE METROPOLITAN MUSEUM OF ART

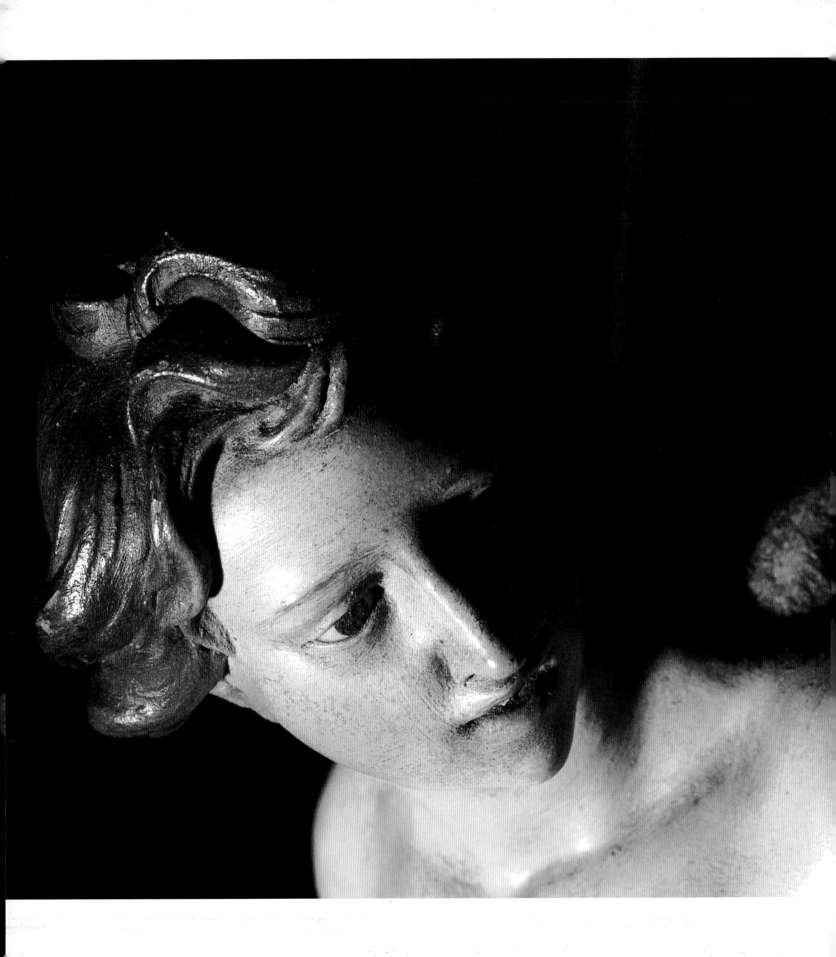

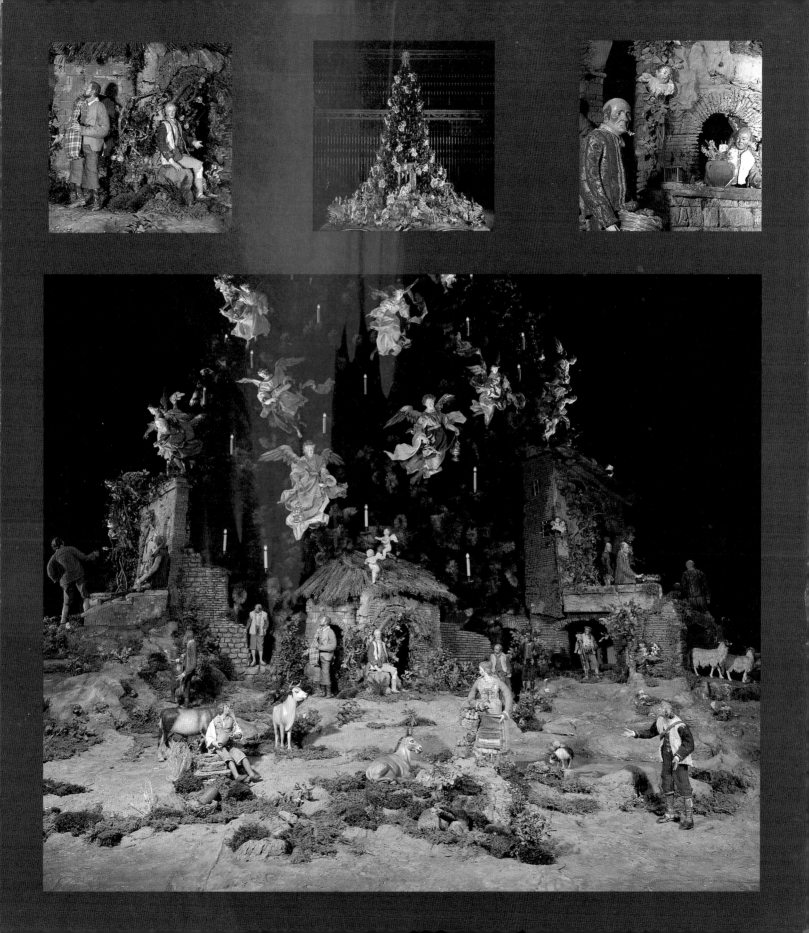

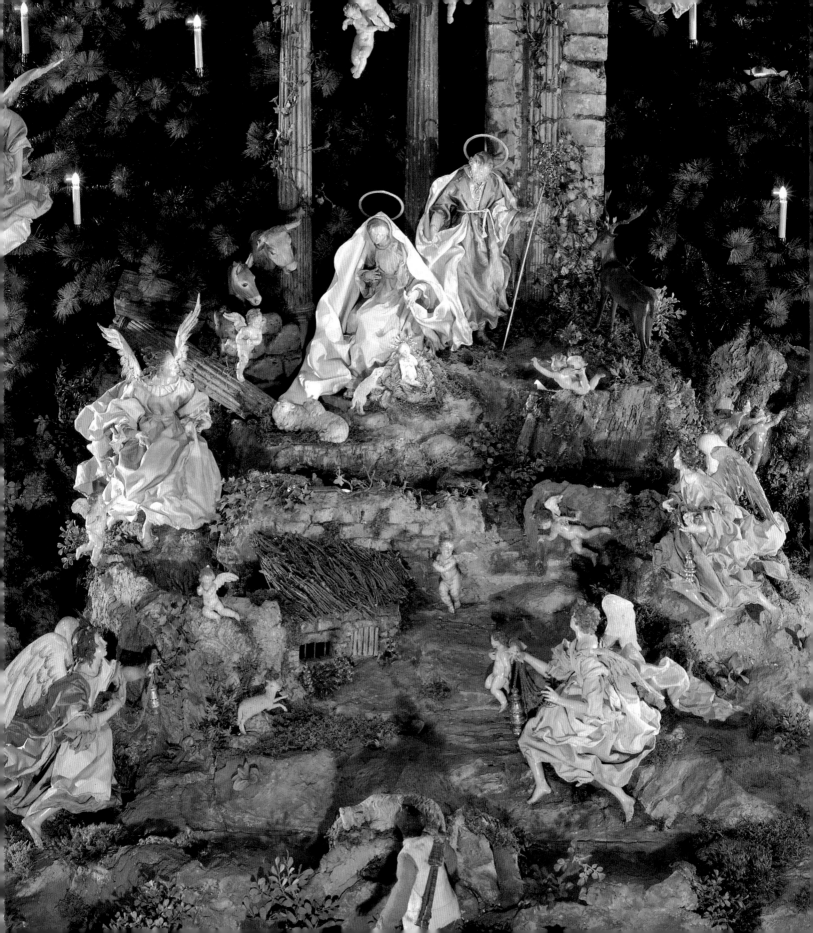

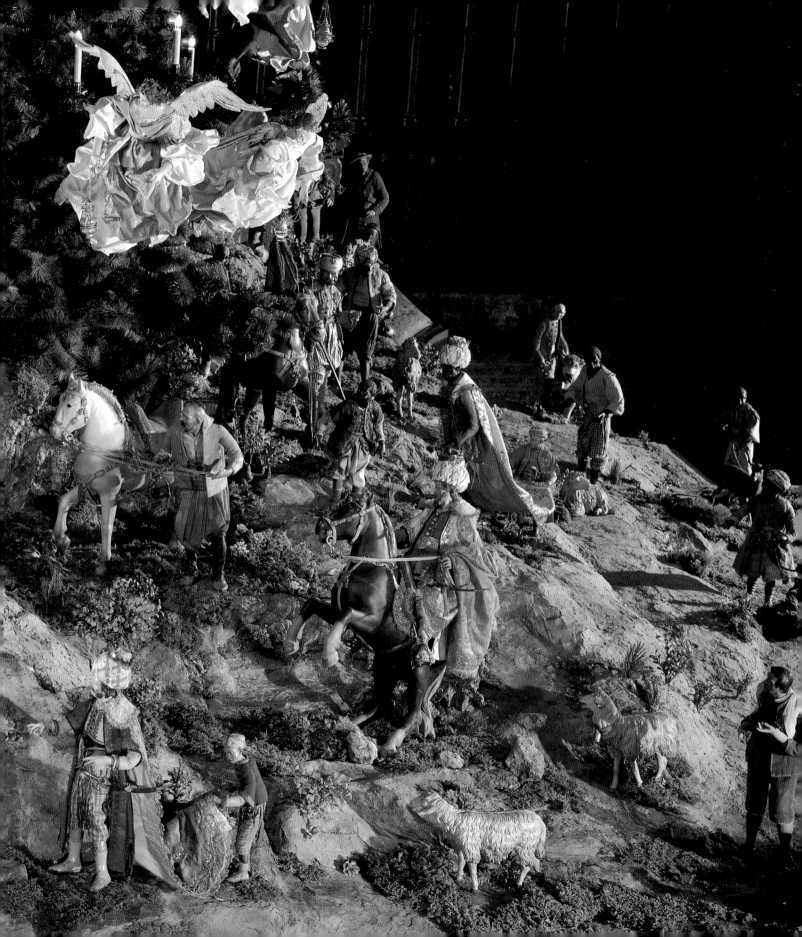

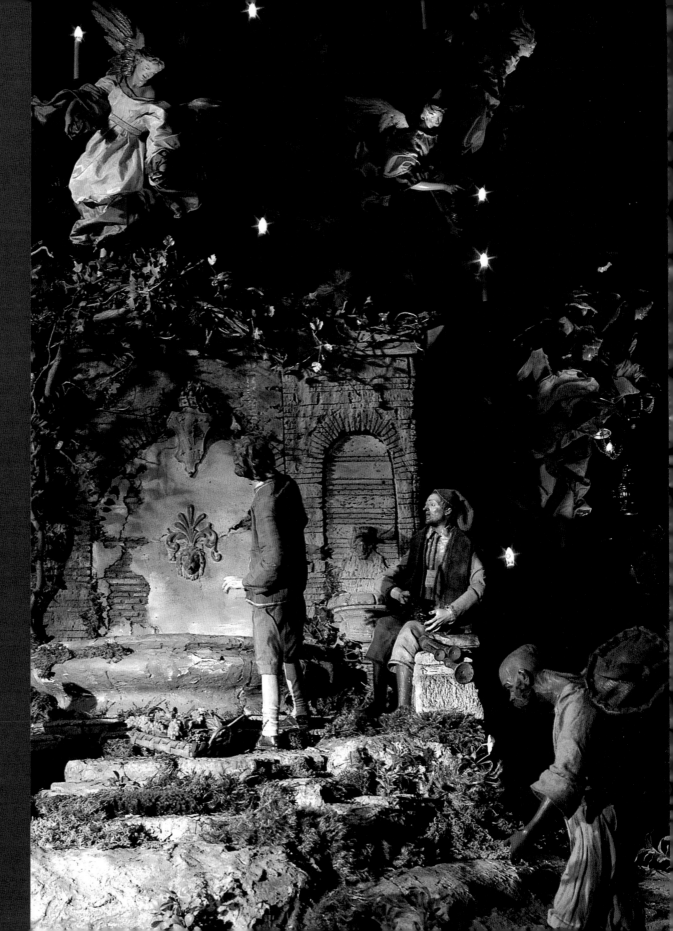

Harry N. Abrams, Inc.

Printed in Japan

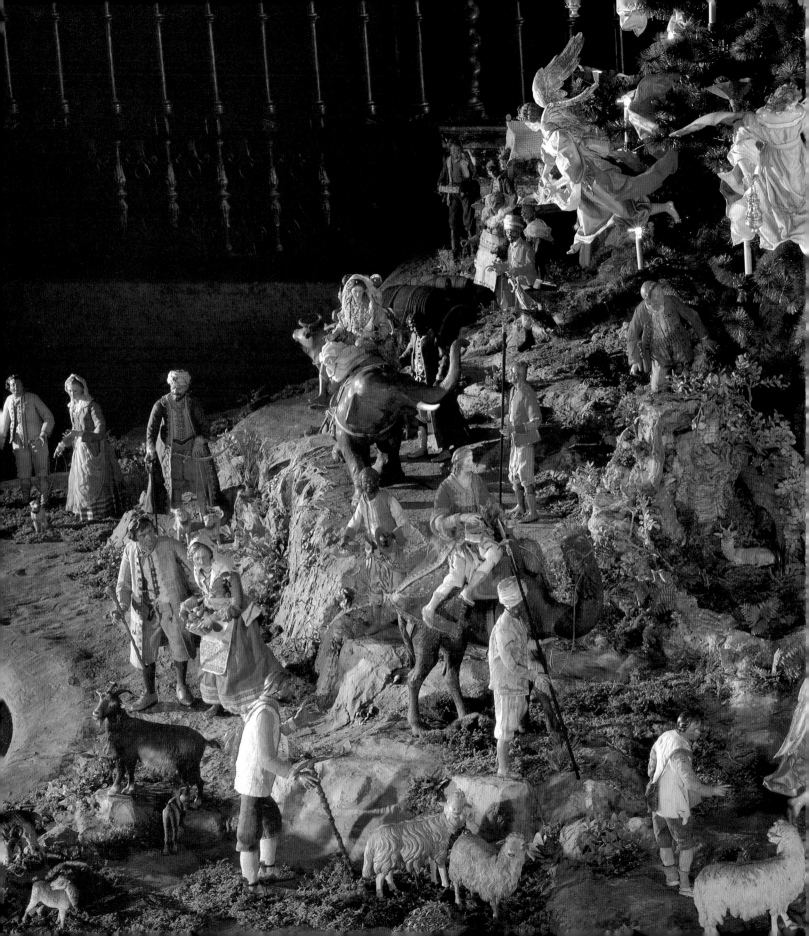

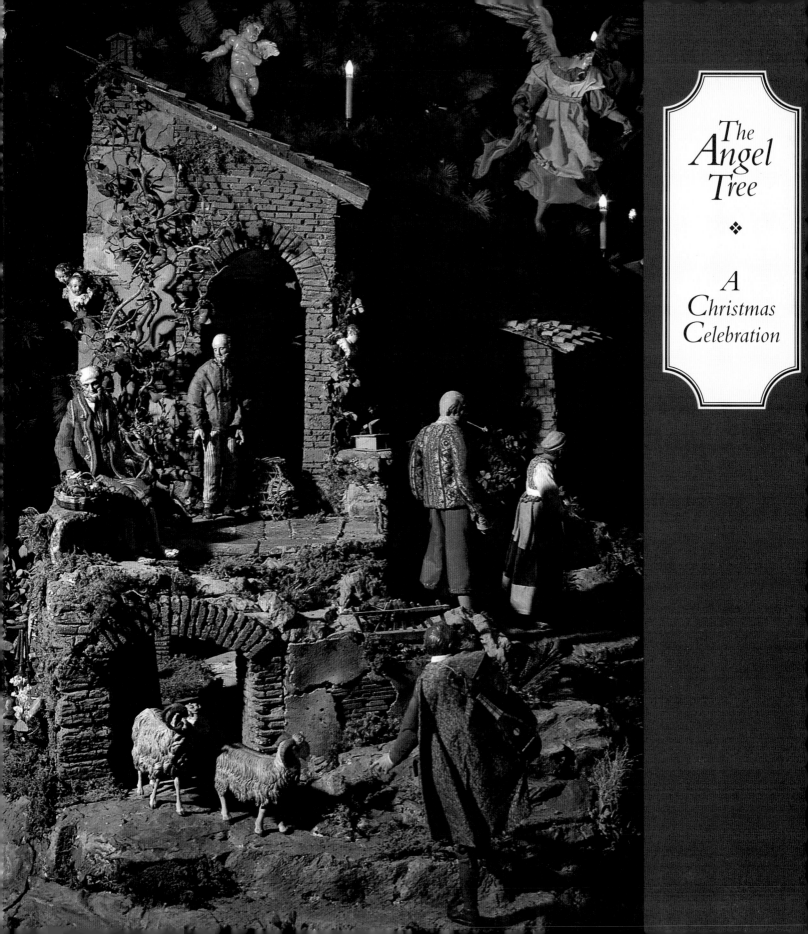

The
Angel
Tree

❖

A
Christmas
Celebration

The Christmas Story

. . . the angel Gabriel was sent from God unto a city of Galilee, named Nazareth,

To a virgin espoused to a man whose name was Joseph, of the house of David; and the virgin's name *was* Mary.

And the angel came in unto her, and said, Hail, *thou that art* highly favoured, the Lord *is* with thee: blessed *art* thou among women.

And when she saw *him*, she was troubled at his saying, and cast in her mind what manner of salutation this should be.

And the angel said unto her, Fear not, Mary: for thou hast found favour with God.

And, behold, thou shalt conceive in thy womb, and bring forth a son, and shalt call his name JESUS.

He shall be great, and shall be called the Son of the Highest: and the Lord God shall give unto him the throne of his father David:

And he shall reign over the house of Jacob for ever; and of his kingdom there shall be no end.

LUKE 1:26–33

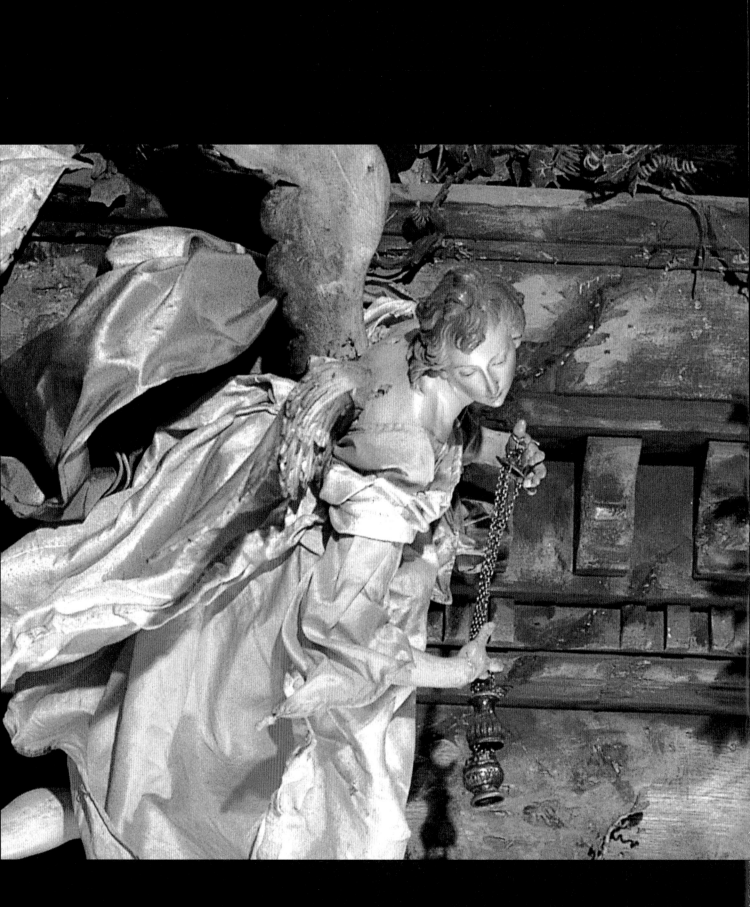

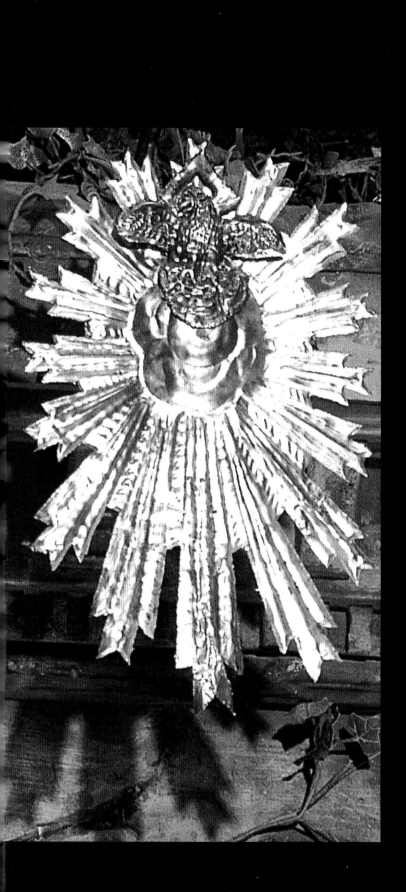

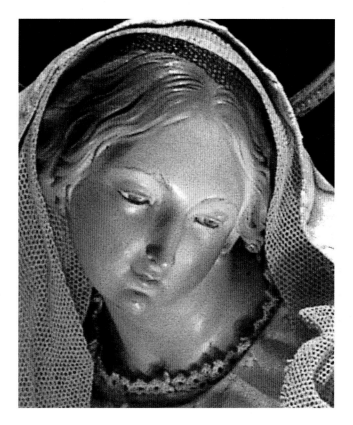

Then said Mary unto the angel, How shall this be, seeing I know not a man?

And the angel answered and said unto her, The Holy Ghost shall come upon thee, and the power of the Highest shall overshadow thee: therefore also that holy thing which shall be born of thee shall be called the Son of God.

LUKE 1:34–35

13

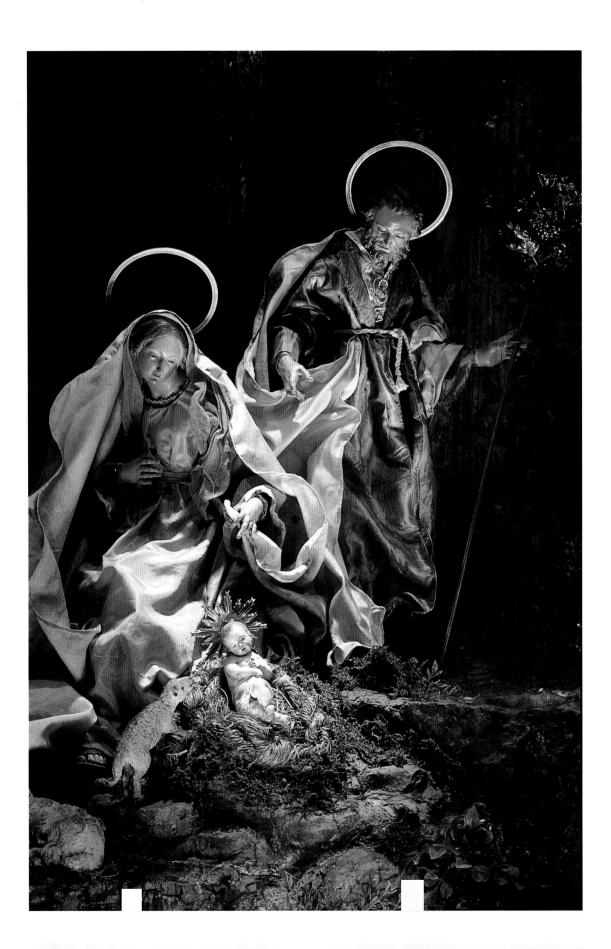

And it came to pass in those
days, that there went out a
decree from Caesar Augustus, that
all the world should be taxed.

And all went to be taxed, every
one into his own city.

And Joseph also went up from
Galilee, out of the city of Nazareth,
into Judaea, unto the city of
David, which is called Bethlehem;
(because he was of the house and
lineage of David:)

To be taxed with Mary his
espoused wife, being great with child.

And so it was, that, while they
were there, the days were accomplished
that she should be delivered.

And she brought forth her
firstborn son, and wrapped him
in swaddling clothes, and laid him
in a manger; because there was no
room for them in the inn.

And there were in the same
country shepherds abiding in the
field, keeping watch over their
flock by night.

And, lo, the angel of the Lord
came upon them, and the glory of
the Lord shone round about them:
and they were sore afraid.

LUKE 2:1, 3–9

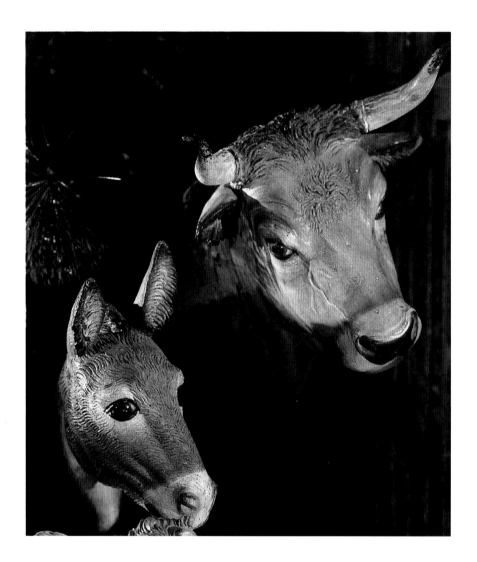

"Be still, and know that I am God . . ."

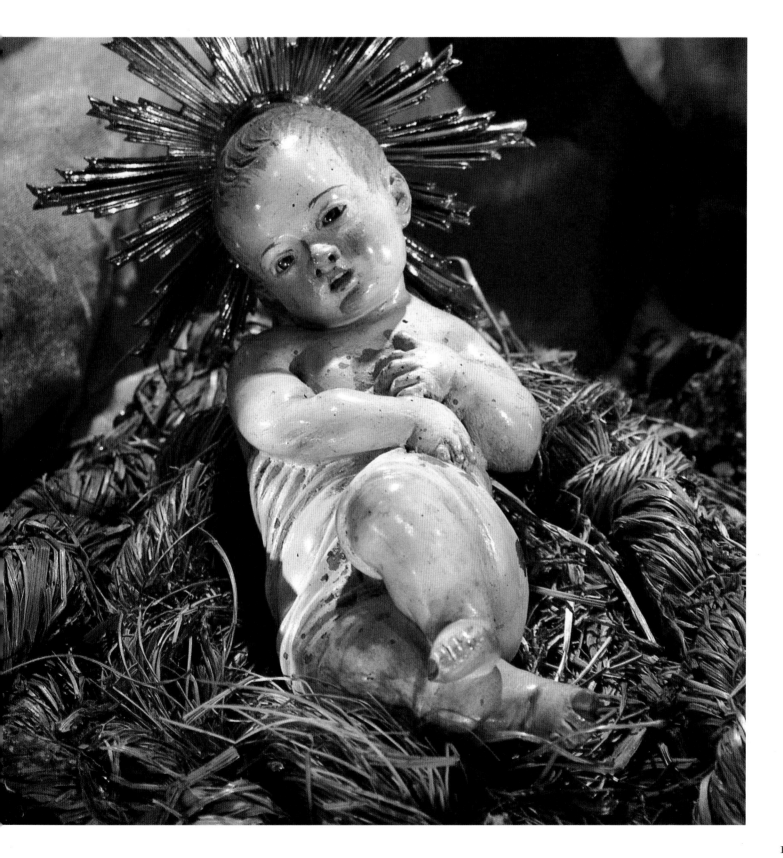

And the angel said unto them, Fear not: for, behold, I bring you good tidings of great joy, which shall be to all people.

For unto you is born this day in the city of David a Saviour, which is Christ the Lord.

And this *shall* be a sign unto you; Ye shall find the babe wrapped in swaddling clothes, lying in a manger.

And suddenly there was with the angel a multitude of the heavenly host praising God, and saying,

Glory to God in the highest, and on earth peace, good will toward men.

And it came to pass, as the angels were gone away from them into heaven, the shepherds said one to another, Let us now go even unto Bethlehem, and see this thing which is come to pass, which the Lord hath made known unto us.

And they came with haste, and found Mary, and Joseph, and the babe lying in a manger.

And when they had seen *it,* they made known abroad the saying which was told them concerning this child.

And all they that heard *it* wondered at those things which were told them by the shepherds.

But Mary kept all these things, and pondered *them* in her heart.

And the shepherds returned, glorifying and praising God for all the things that they had heard and seen, as it was told unto them.

LUKE 2:10-20

". . . rejoice in his light."

JOHN 5:35

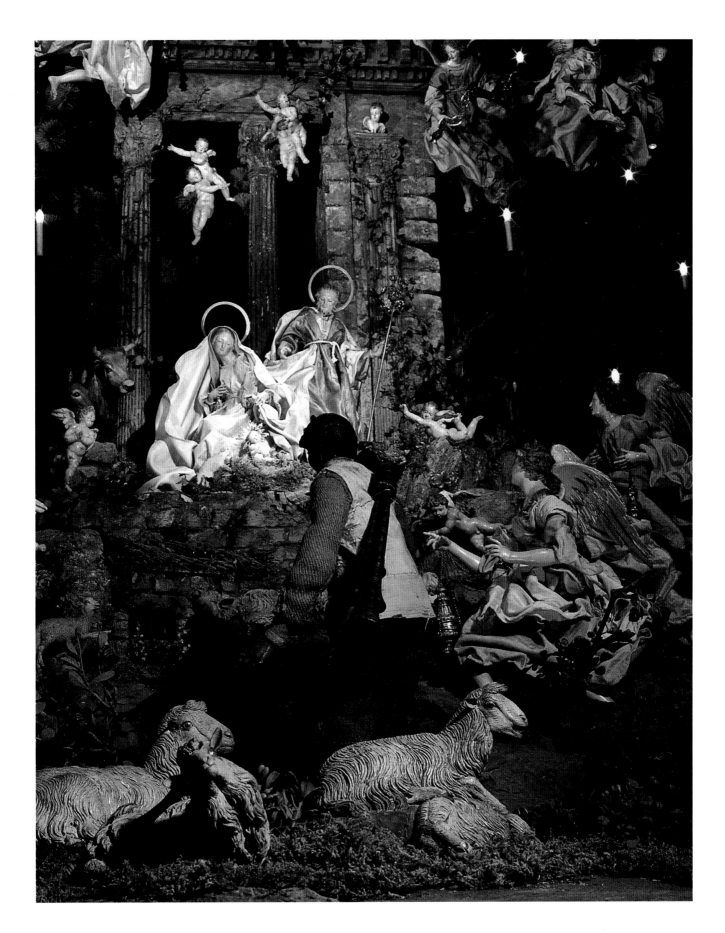

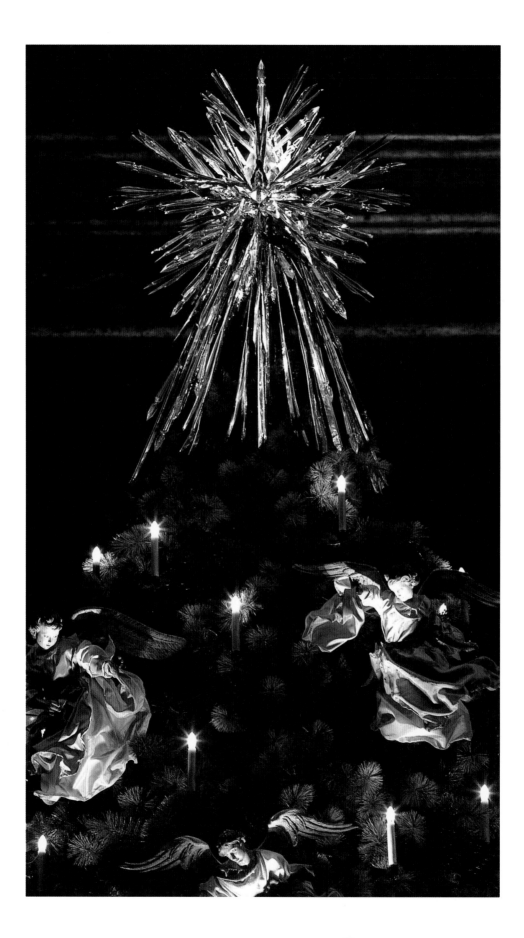

Now when Jesus was born in Bethlehem of Judaea in the days of Herod the king, behold, there came wise men from the east to Jerusalem,

Saying, Where is he that is born King of the Jews? for we have seen his star in the east, and are come to worship him.

When Herod the king had heard *these things,* he was troubled, and all Jerusalem with him.

MATTHEW 2:1–3

"The heavens declare the glory of God . . ."

PSALMS 19:1

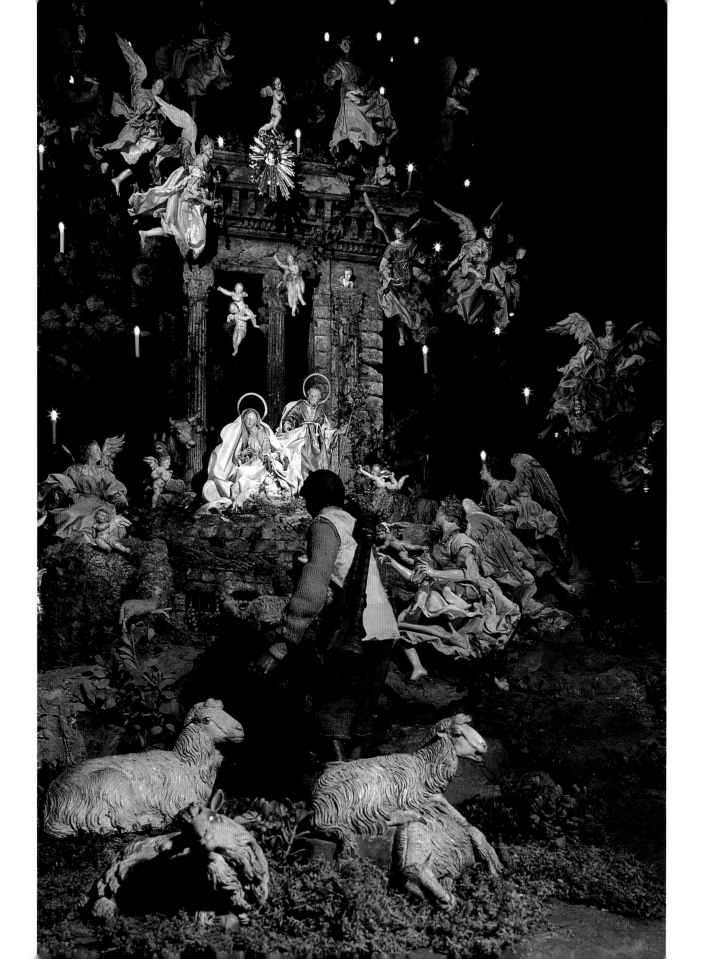

Then Herod, when he had privily called the wise men, enquired of them diligently what time the star appeared.

And he sent them to Bethlehem, and said, Go and search diligently for the young child; and when ye have found *him,* bring me word again, that I may come and worship him also.

When they had heard the king, they departed; and, lo, the star, which they saw in the east, went before them, till it came and stood over where the young child was.

When they saw the star, they rejoiced with exceeding great joy.

And when they were come into the house, they saw the young child with Mary his mother, and fell down, and worshipped him: and when they had opened their treasures, they presented unto him gifts; gold, and frankincense, and myrrh.

MATTHEW 2:7–11

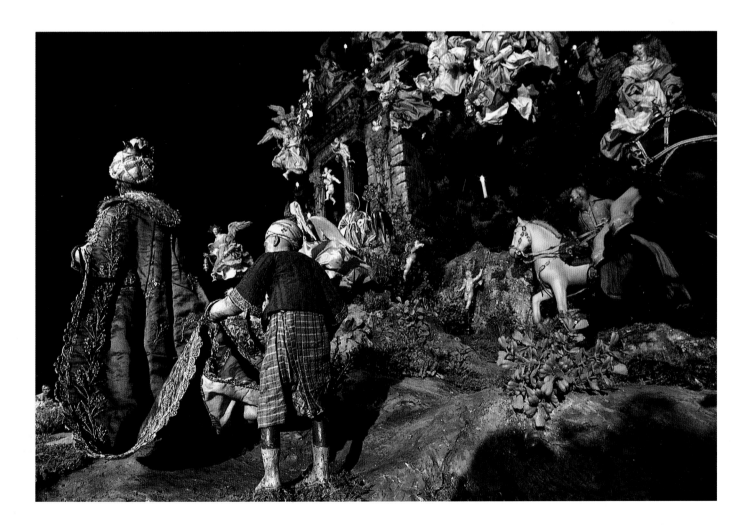

23

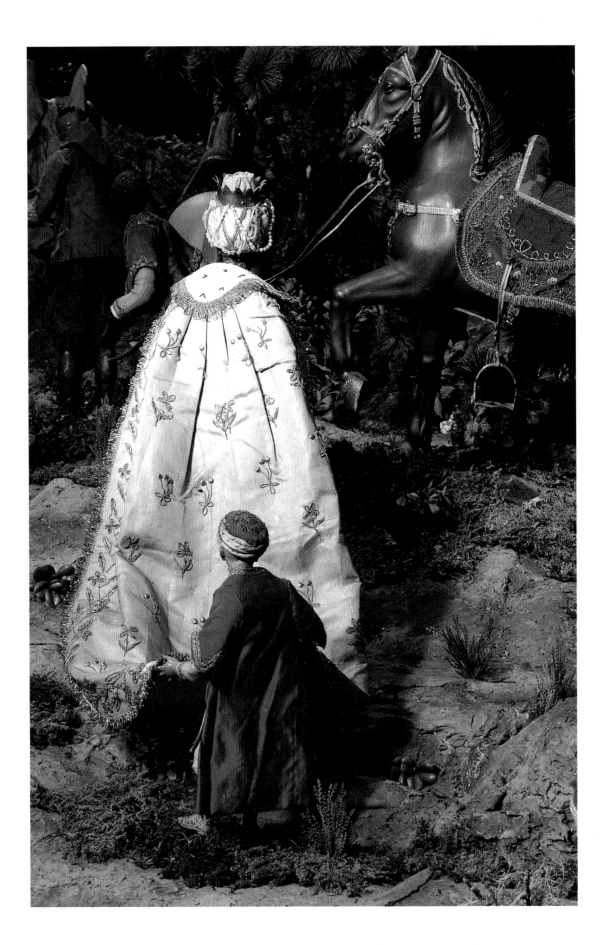

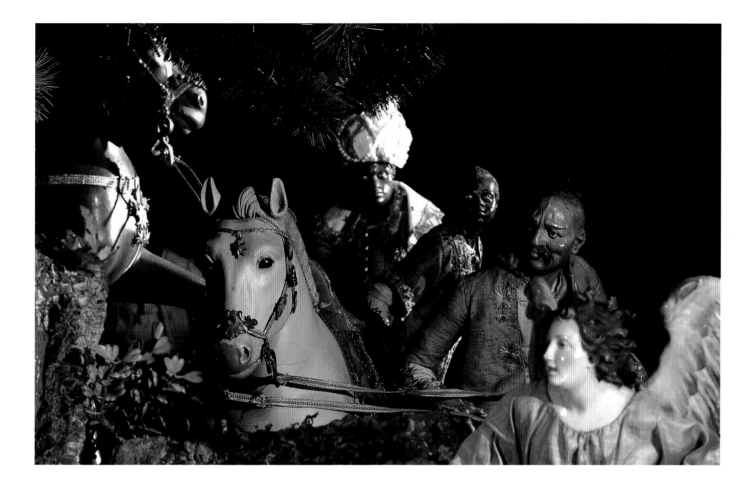

And being warned of God in a dream that they should not return to Herod, they departed into their own country another way.

And when they were departed, behold, the angel of the Lord appeareth to Joseph in a dream, saying, Arise, and take the young child and his mother, and flee into Egypt, and be thou there until I bring thee word: for Herod will seek the young child to destroy him.

When he arose, he took the young child and his mother by night and departed into Egypt . . .

MATTHEW 2:12–14

But when Herod was dead, behold, an angel of the Lord appeareth in a dream to Joseph in Egypt.

Saying, Arise, and take the young child and his mother, and go into the land of Israel: for they are dead which sought the young child's life.

And he arose, and took the young child and his mother, and came into the land of Israel.

MATTHEW 2:19–21

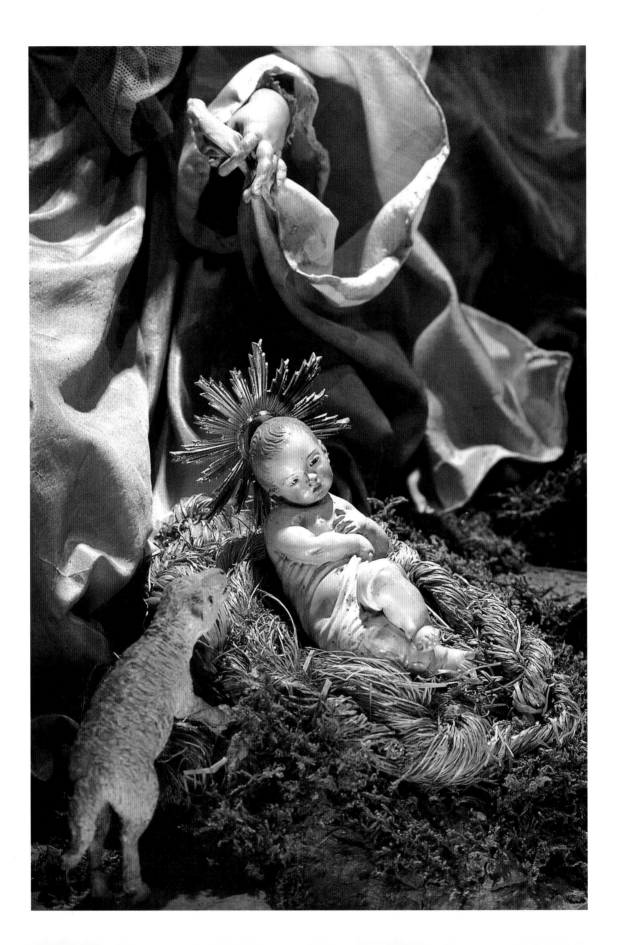

For unto us a child is born,
unto us a son is given: and the
government shall be upon his
shoulder: and his name shall be called
Wonderful . . . The Prince of Peace.

ISAIAH 9:6

". . . and a little child shall lead them."

ISAIAH 11:6

An Adoration of Angels

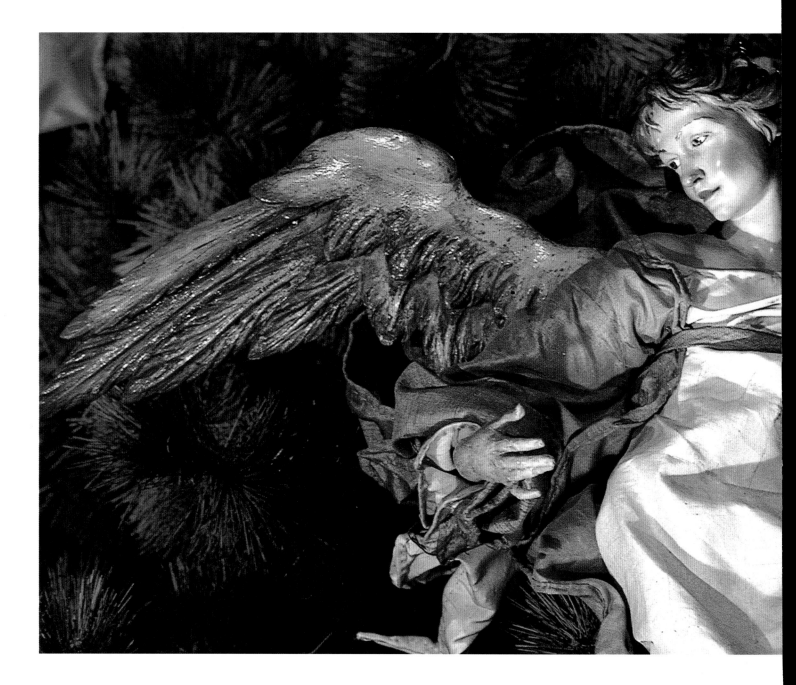

"Behold, I bring you good tidings of great joy . . ."

<div align="right">LUKE 2:10</div>

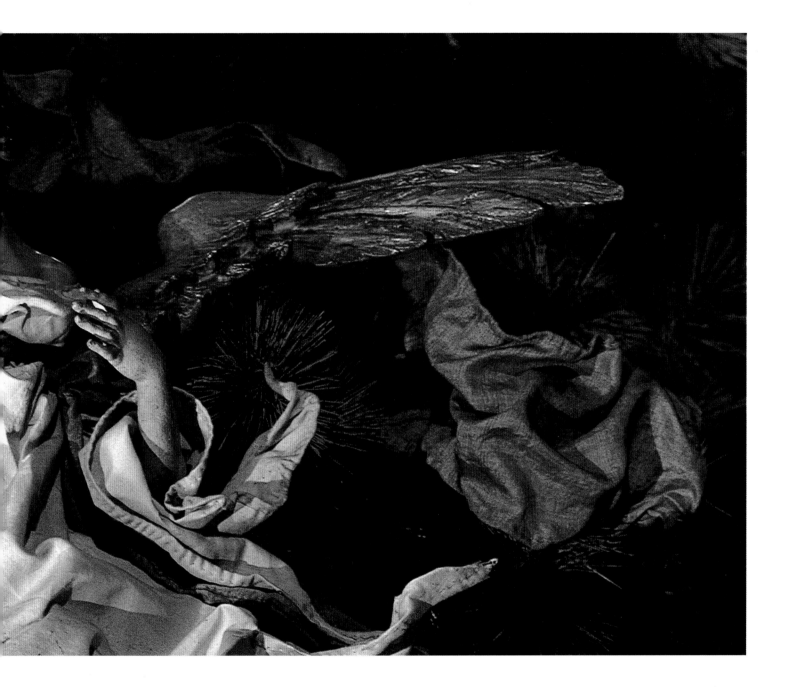

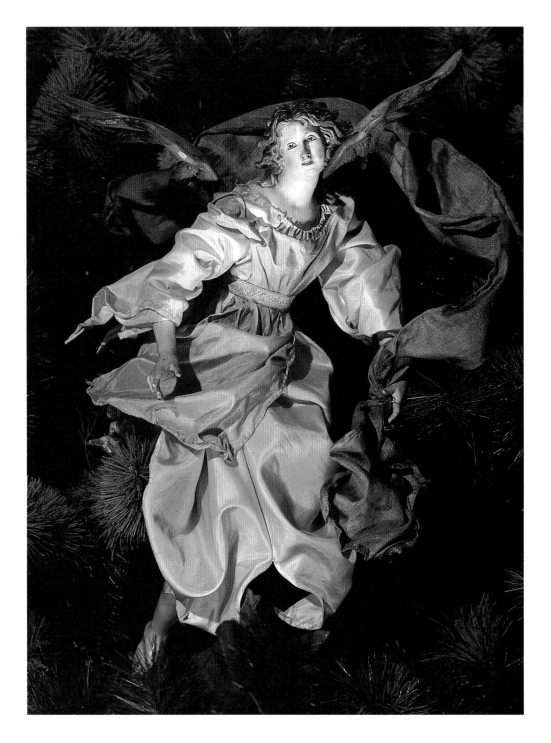

"The Son of man shall send forth his angels . . ."

MATTHEW 13:41

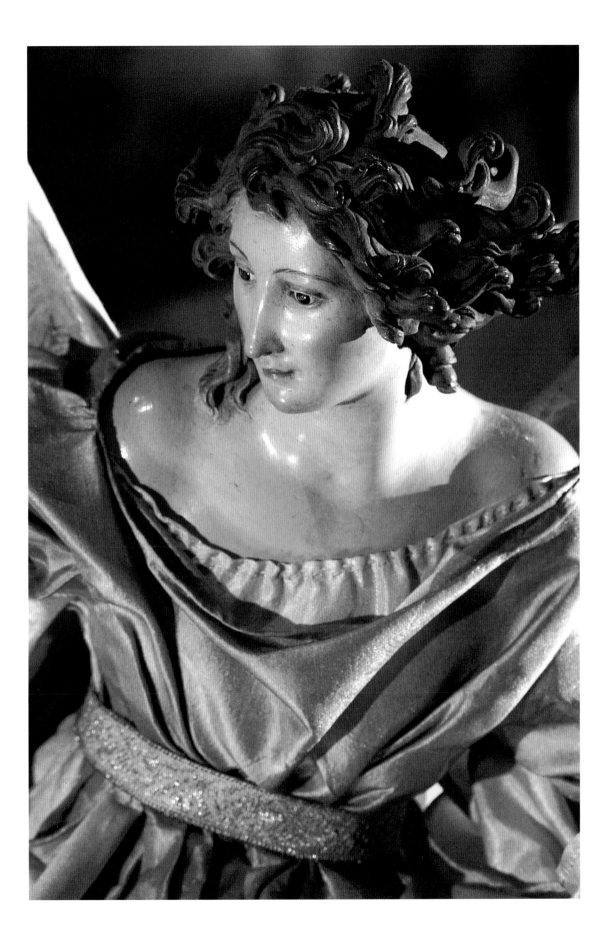

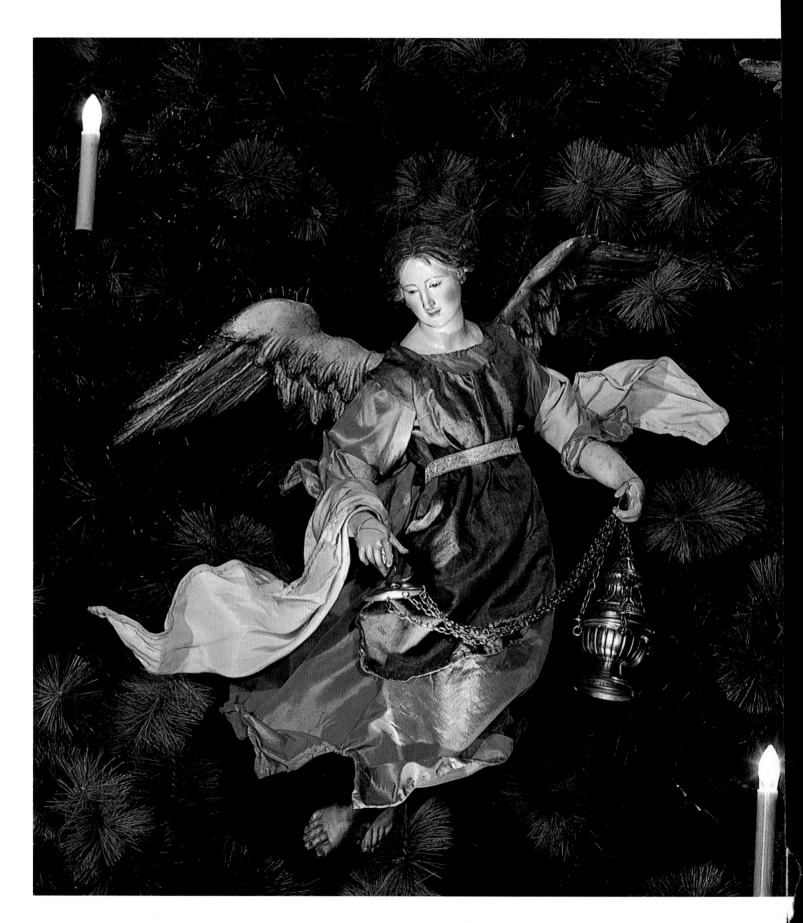

"The Lord . . . will send his angel with thee, and prosper thy way . . ."

GENESIS 24:40

"For the Son of man shall come in the glory of his Father with his angels . . ."

MATTHEW 16:27

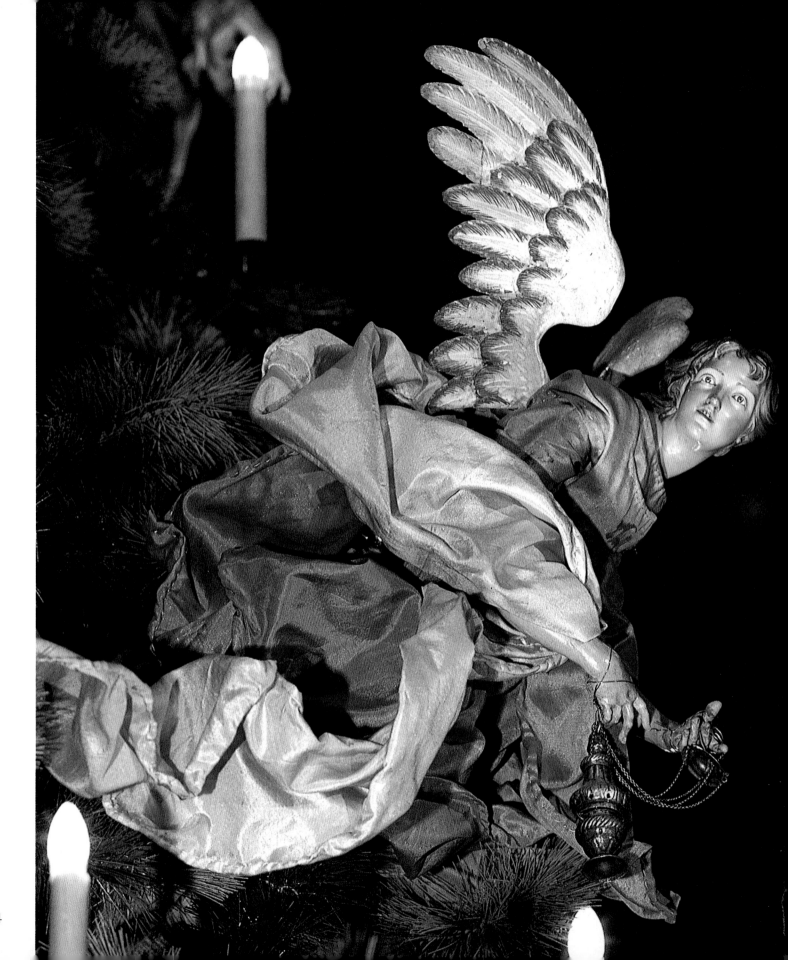

34

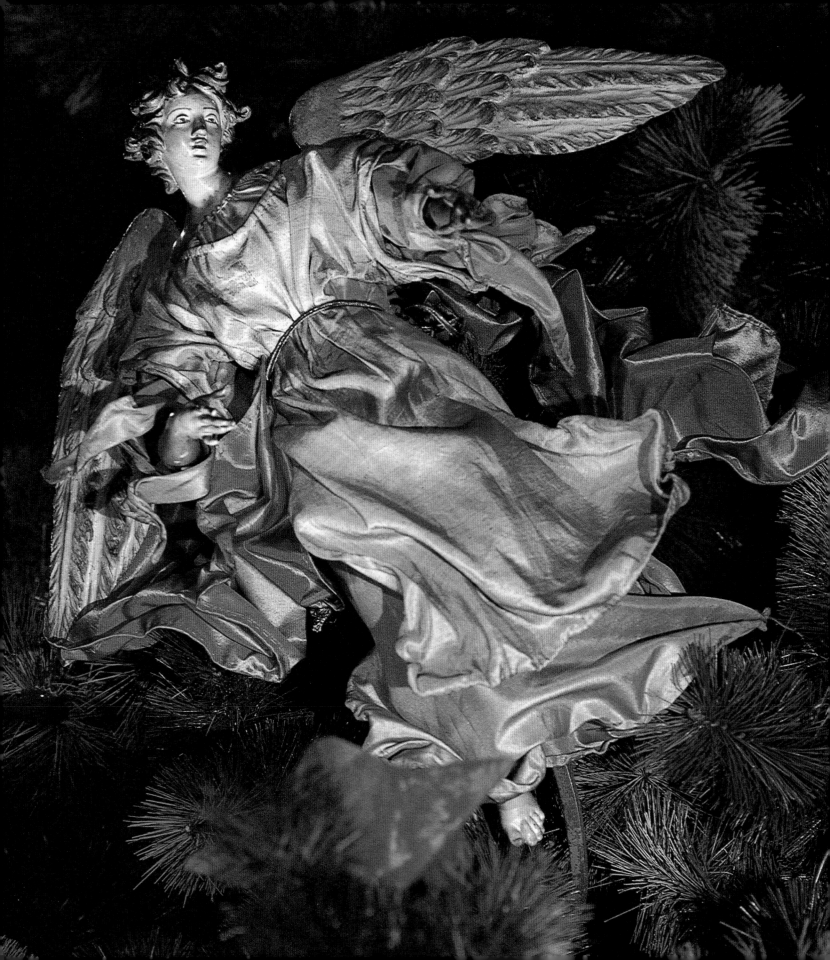

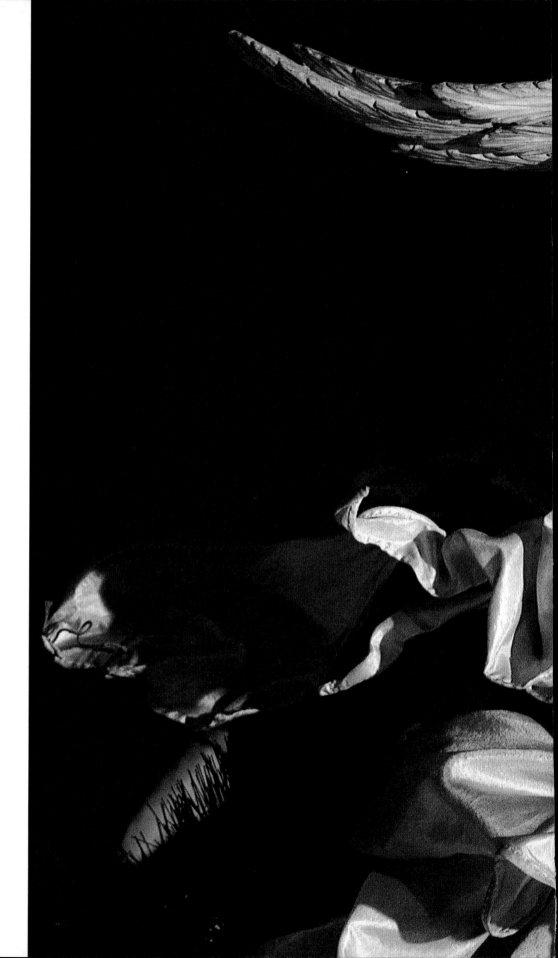

"The angel of
the Lord descended
from heaven . . ."

MATTHEW 28:2

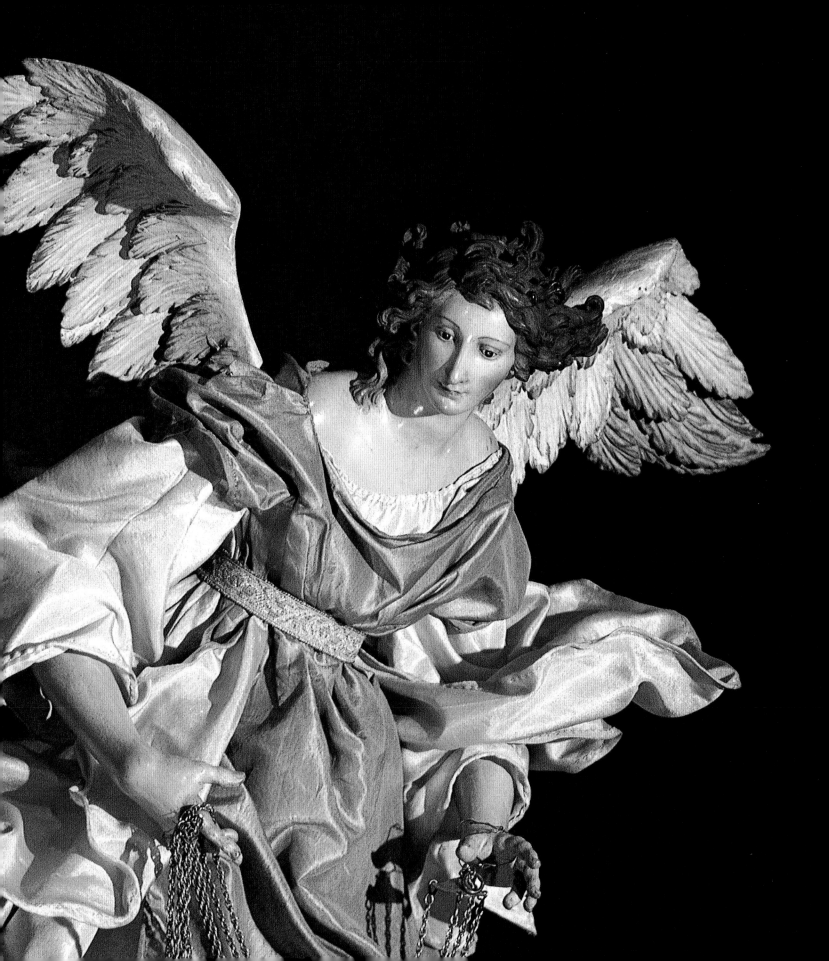

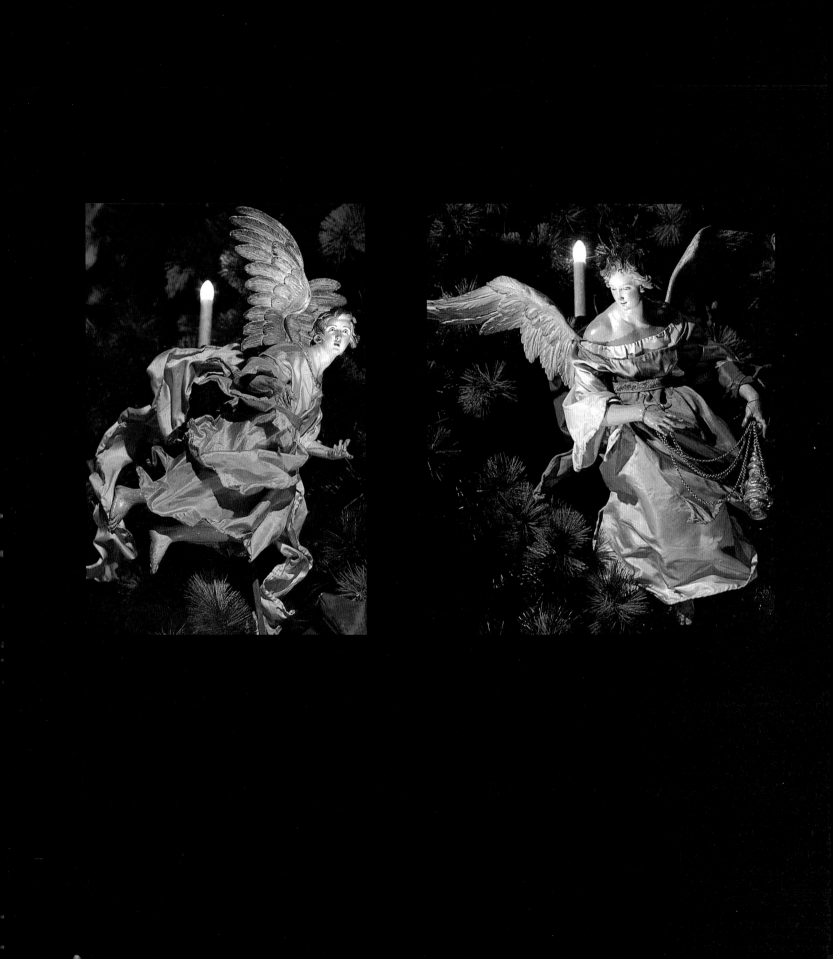

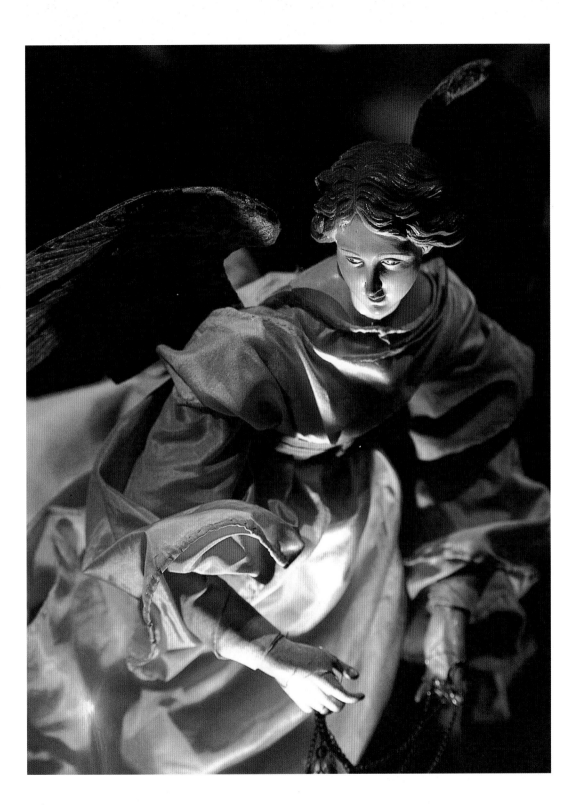

"Praise ye him, all his angels: praise ye him, all his hosts."

PSALMS 148:2

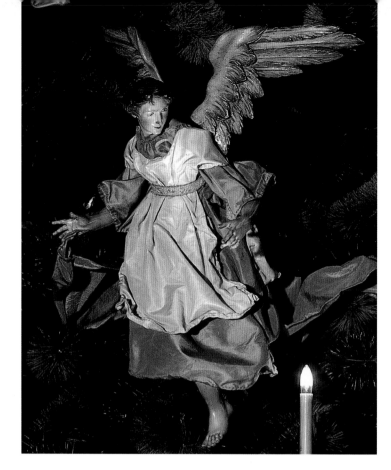

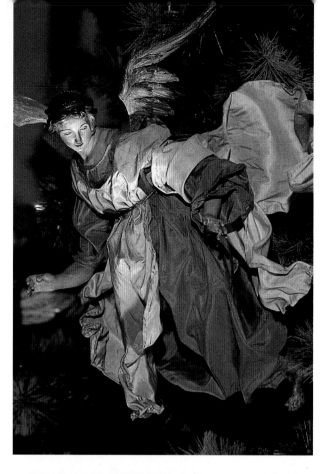

"Bless the Lord, ye his angels . . ."

PSALMS 103:20

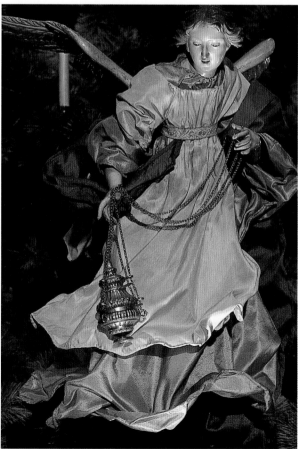

"He shall give his angels charge
over thee . . ."

PSALMS 91:11

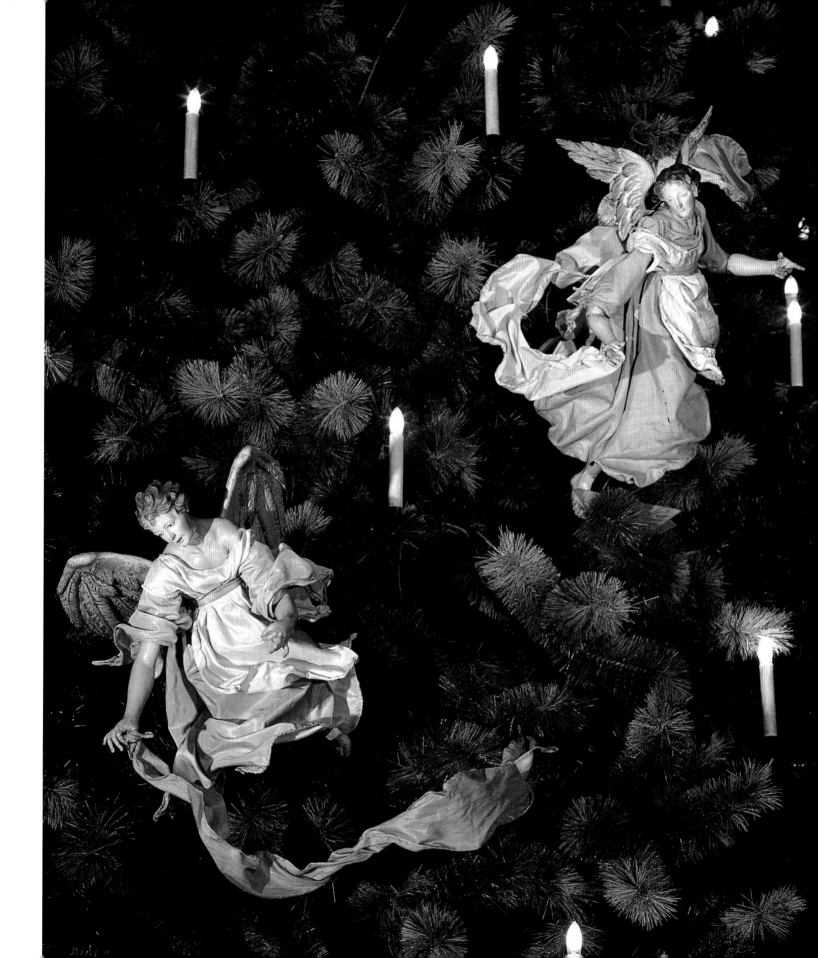

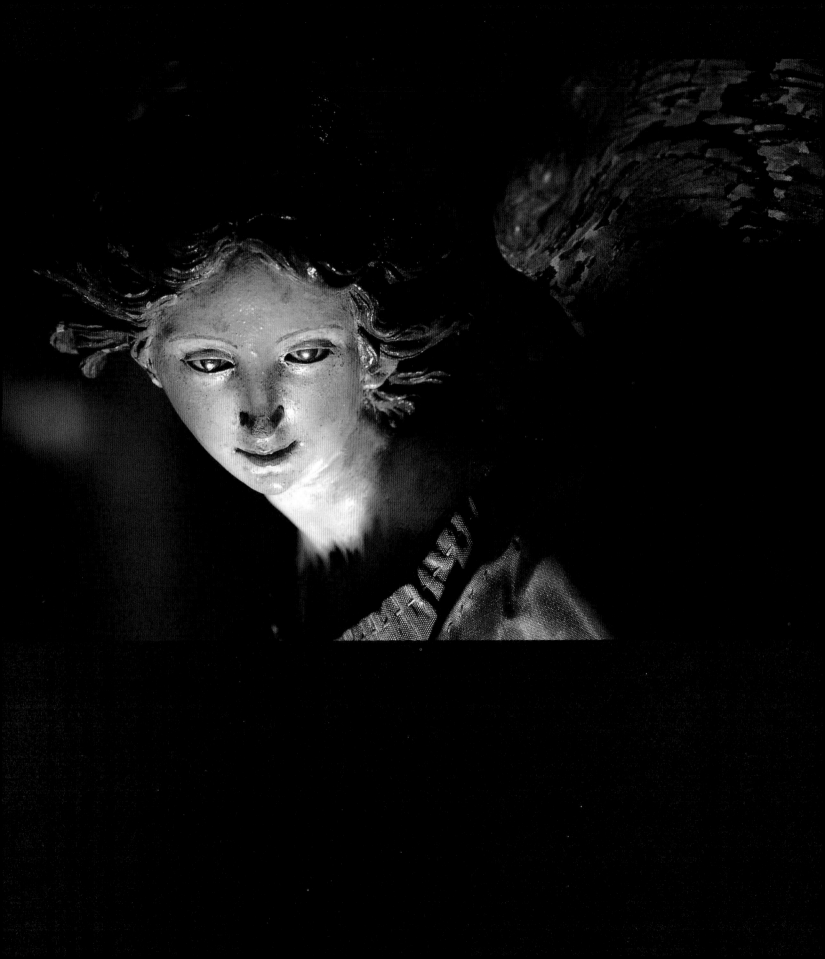

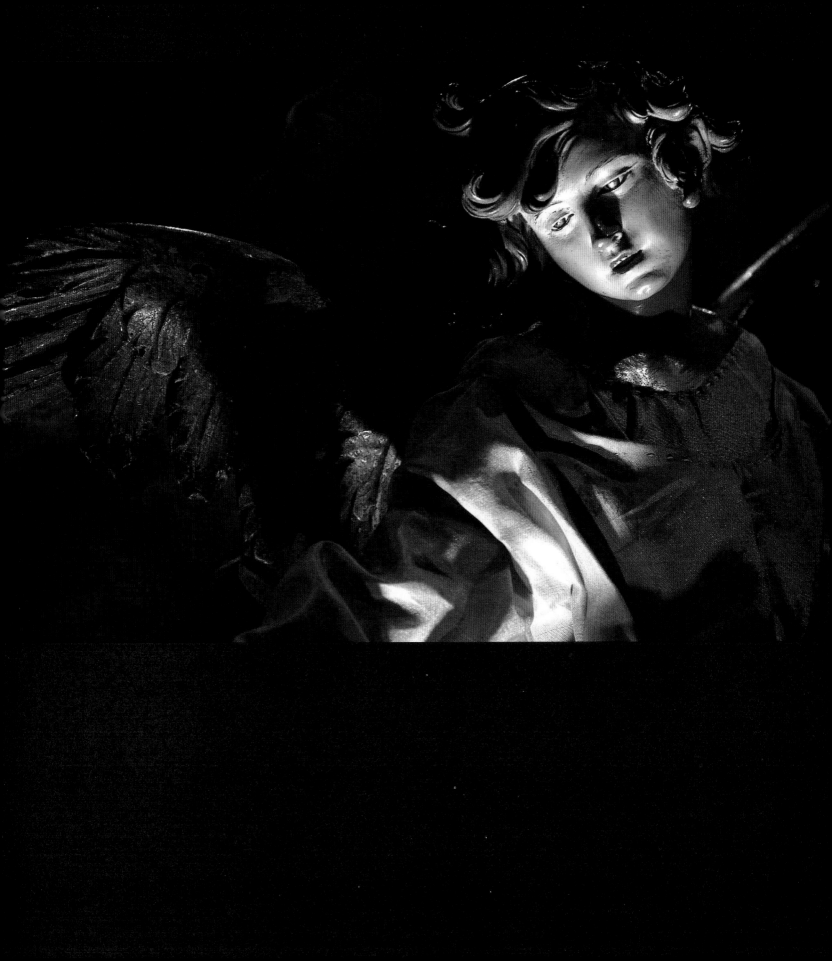

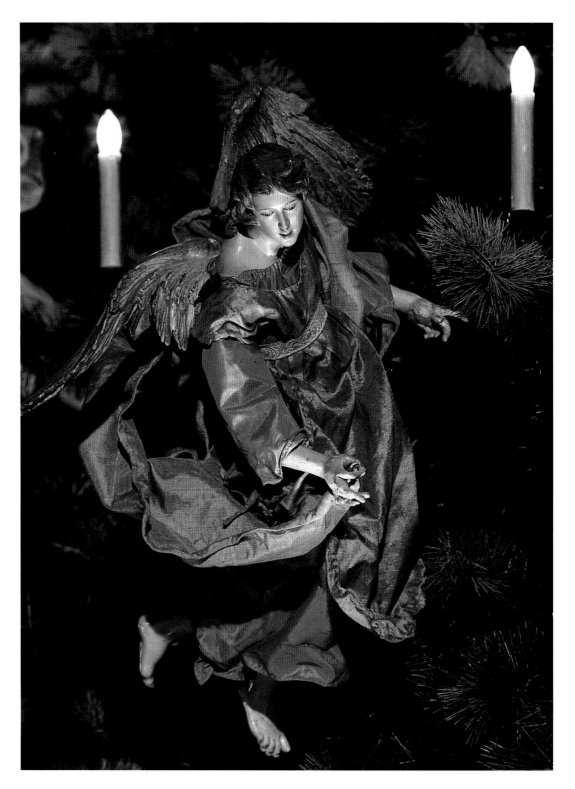

"If I take the wings of the morning,
and dwell in the uttermost parts of the sea;
Even there shall thy hand lead me . . ." PSALMS 139:9–10

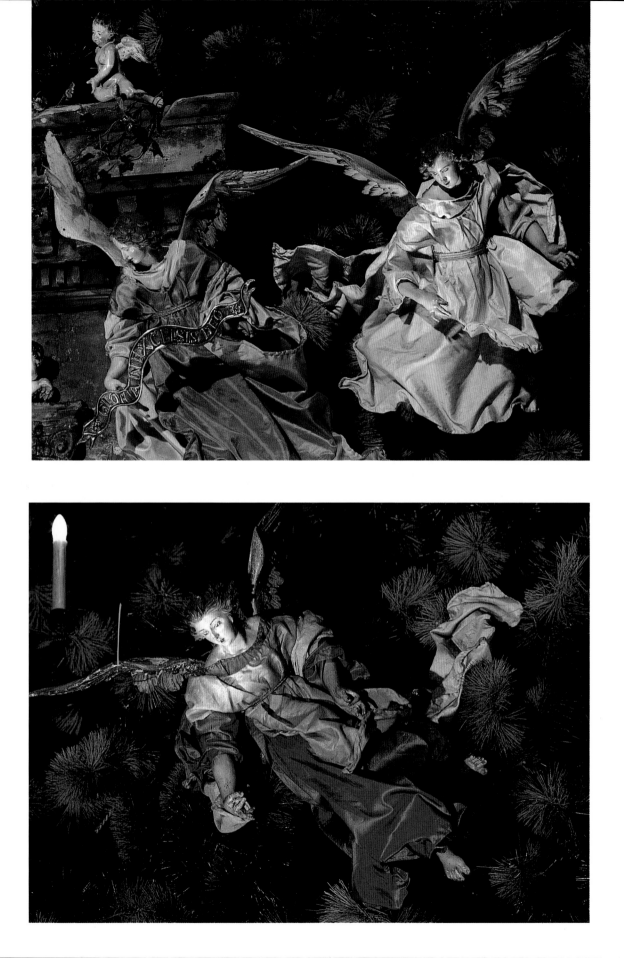

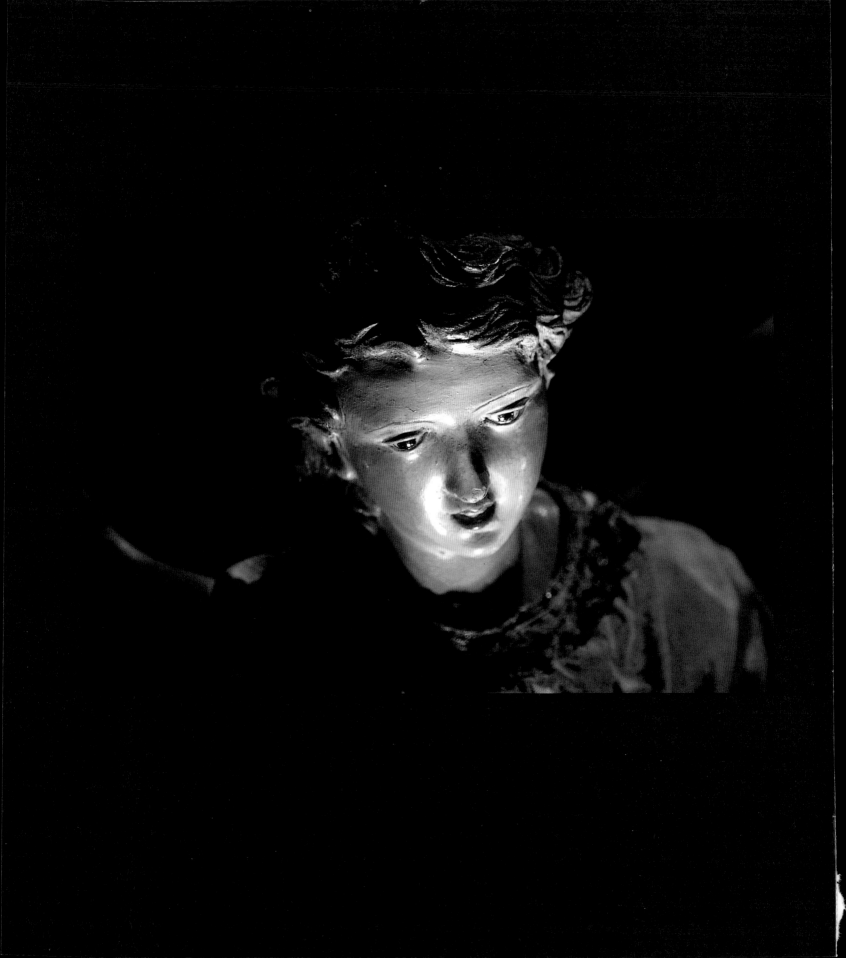

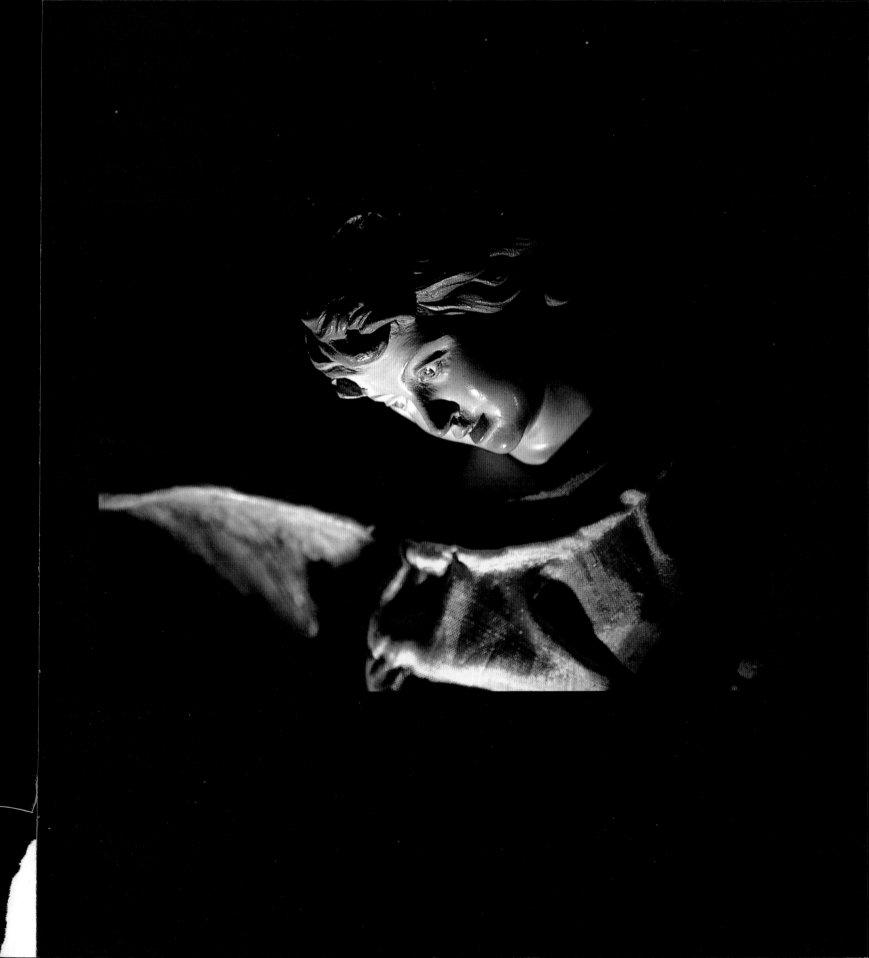

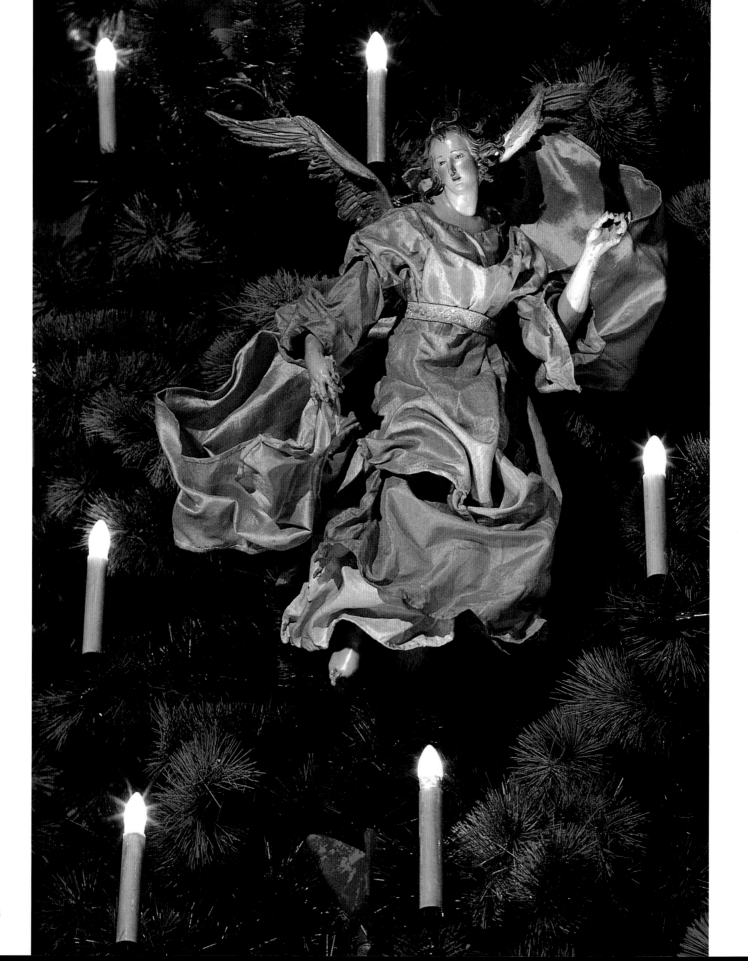

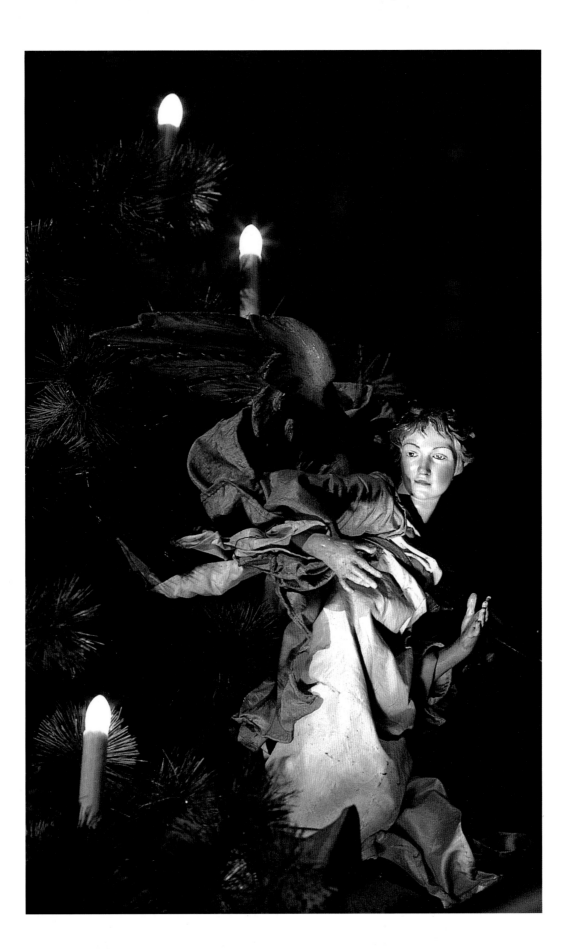

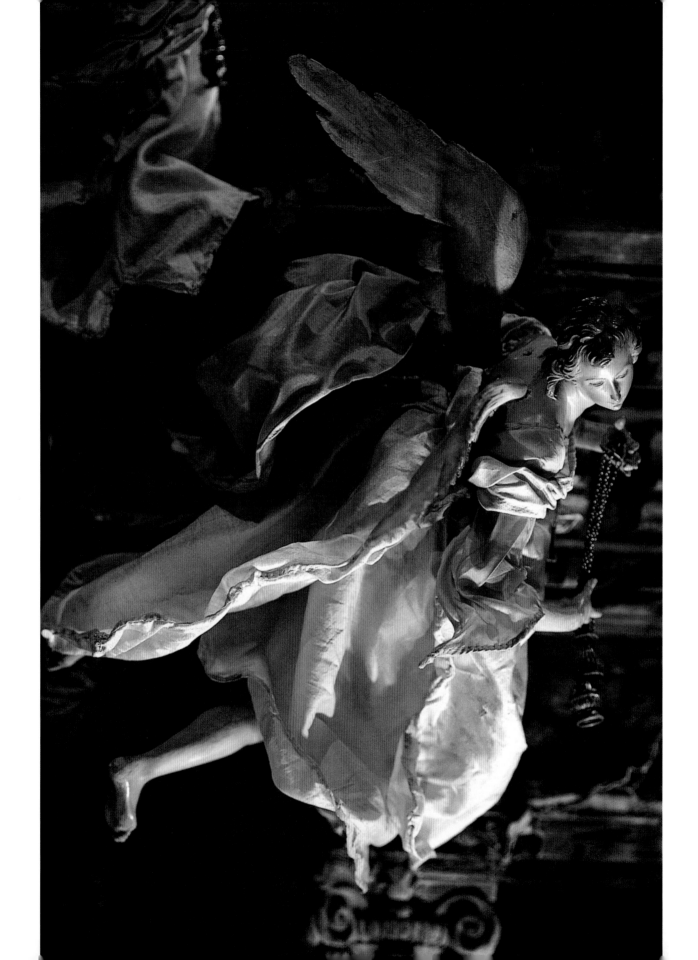

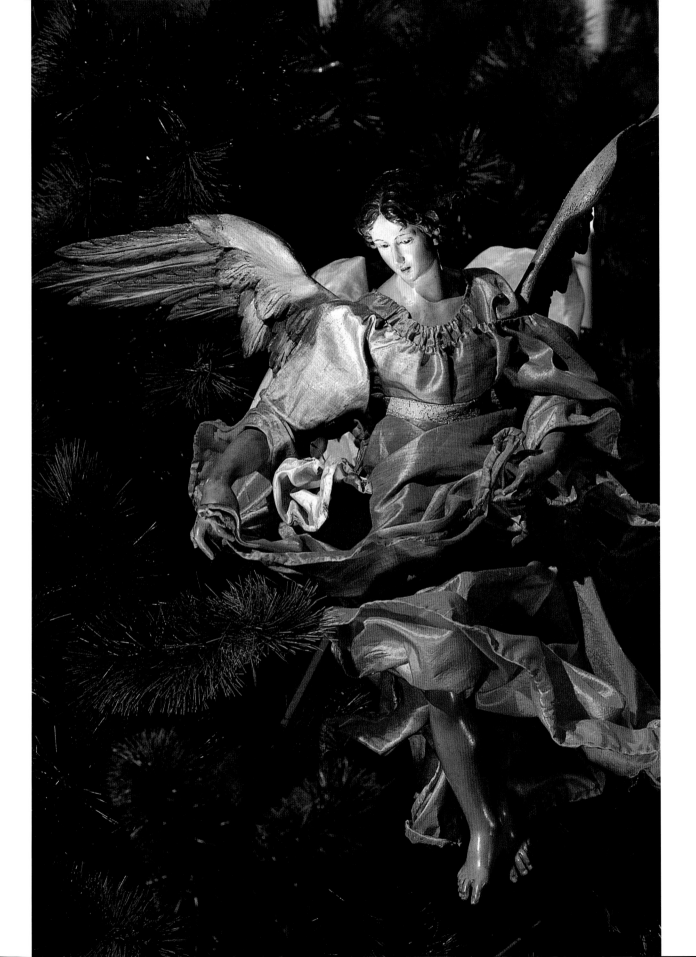

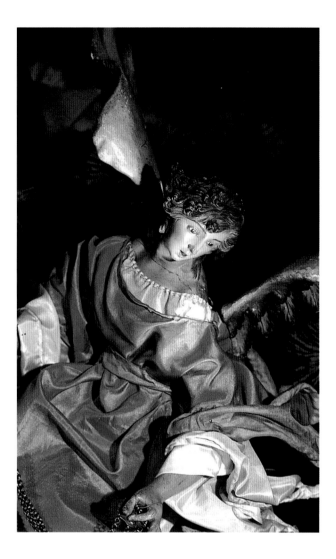

"O Lord, how manifold are thy works! in wisdom hast thou made them all: the earth is full of thy riches."

PSALMS 104:24

"Give unto the Lord the glory due unto his name . . ."

PSALMS 96:8

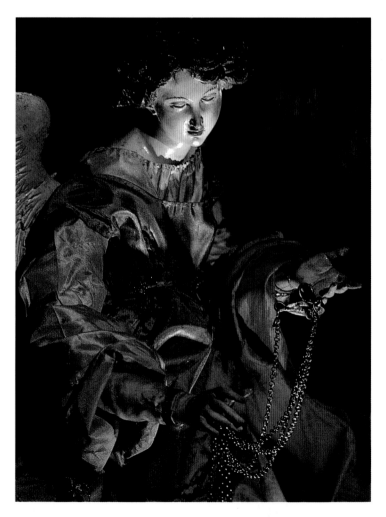

"O sing unto the Lord a new song: sing unto the Lord, all the earth. . .

Honour and majesty are before him: strength and beauty are in his sanctuary." PSALMS 96:1,6

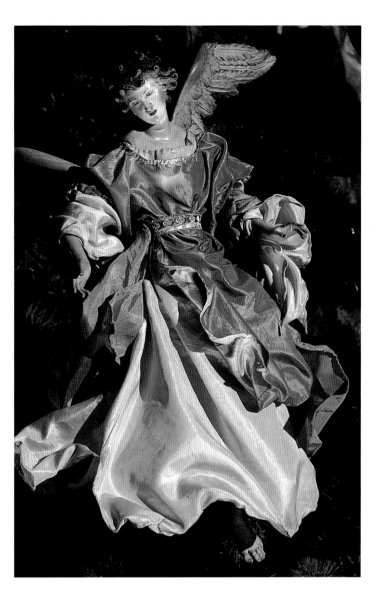

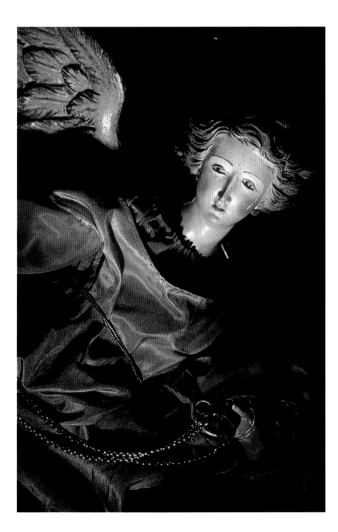

"It is God that girdeth me with strength, and maketh my way perfect." PSALMS 18:32

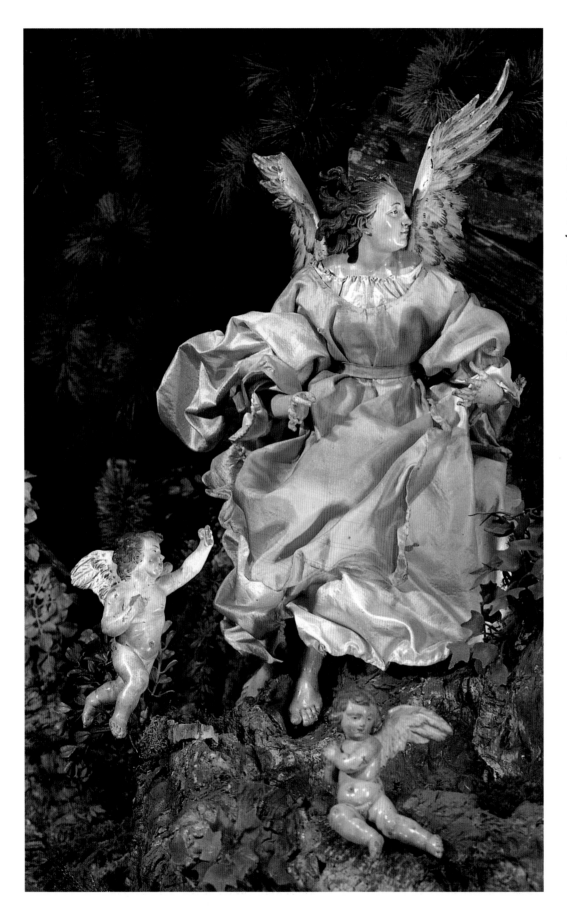

"Thy righteousness
is like the great
mountains; thy
judgments are
a great deep:
O Lord, thou
preservest man
and beast."

PSALMS 36:6

"He hath made
every *thing*
beautiful . . ."

ECCLESIASTES 3:11

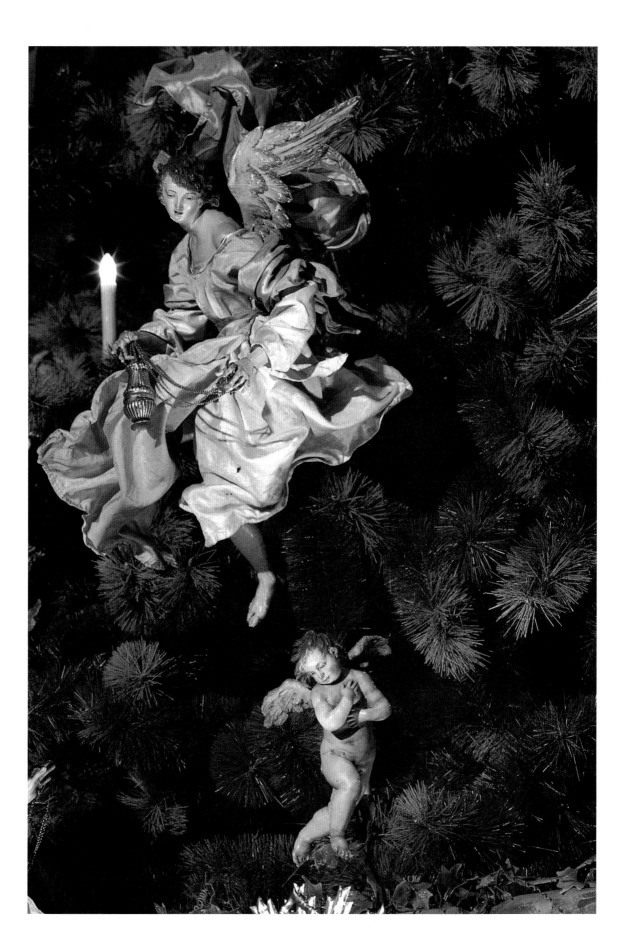

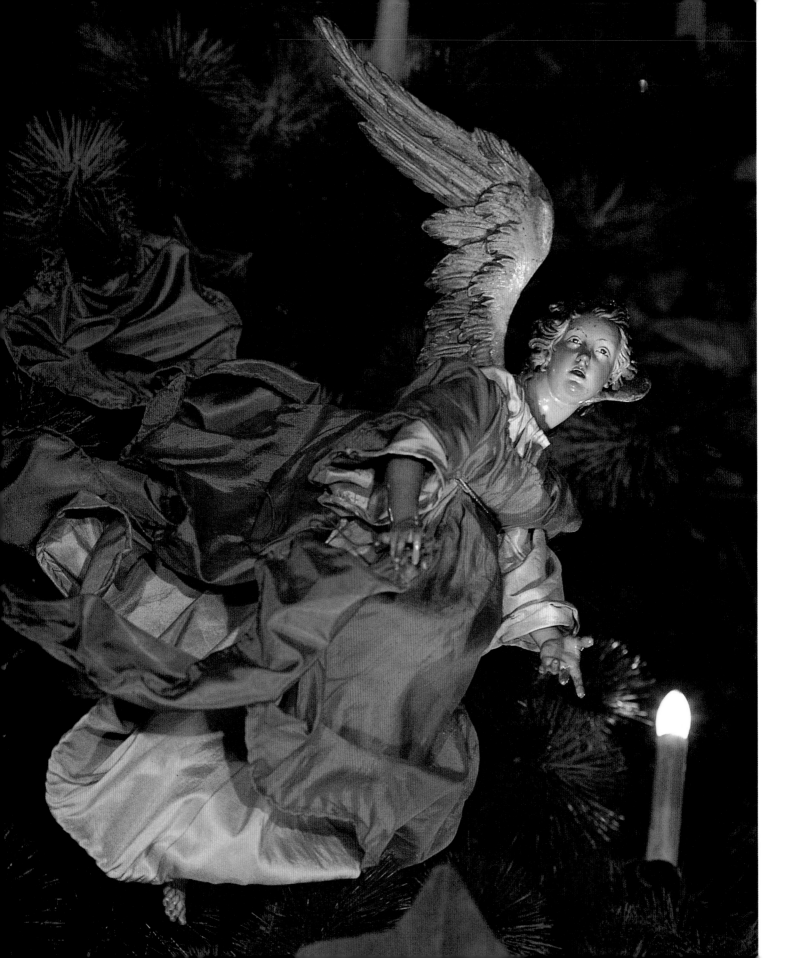

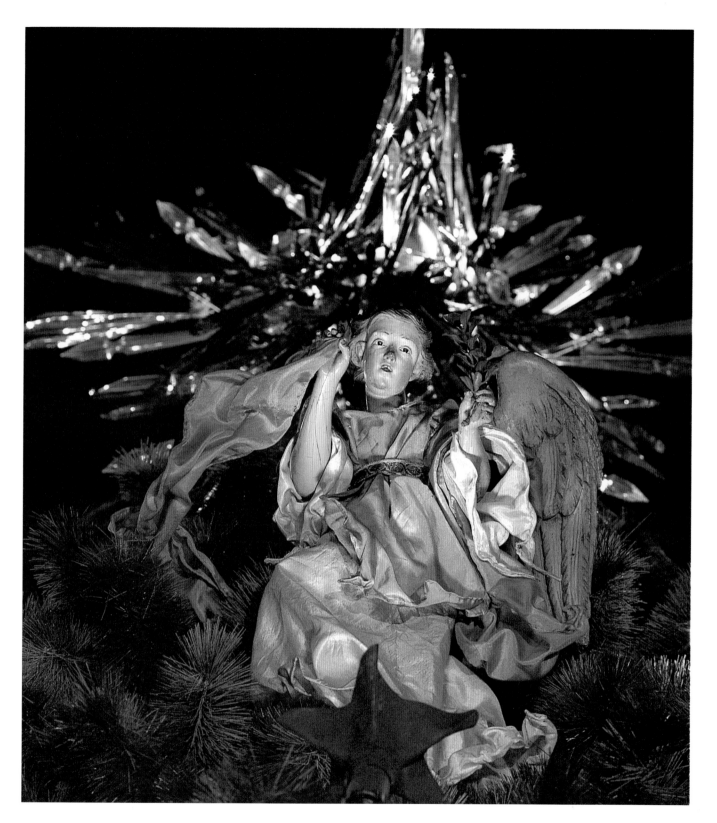

"For with thee is the fountain of life: in thy light shall we see light."

PSALMS 36:9

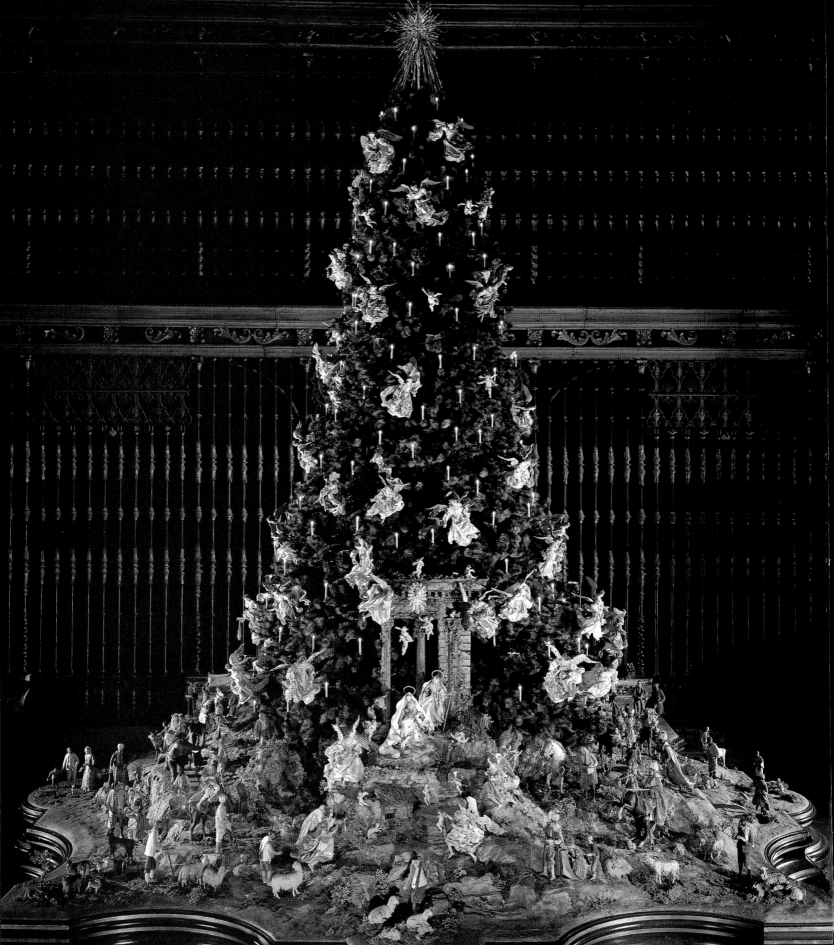

The Story of the Crèche

There is joy in the presence of angels . . . LUKE 15:10

It is said that angels are God's messengers to man: proclaiming, announcing, lighting the way. It was an angel who told Mary she would give birth to the Prince of Peace. This wondrous Nativity is celebrated each Christmas season at The Metropolitan Museum of Art in New York with an exhibition of "The Adoration of Angels." The renowned collection of eighteenth-century Neapolitan crèche figures was given to the Museum by Loretta Hines Howard. Angels of extraordinary beauty encircle a tall Christmas tree that towers above a colorful pageant of people come to praise the Babe.

The figures in the collection are no more than twenty inches in height. The heads are tiny works of art, sculpted in terra cotta and polychromed to perfection. Their flexible bodies are made of hemp, tow, and wire, with arms and legs finely carved in wood. In the dress of eighteenth-century Neapolitans, they create a colorful, lively spectacle on their way to Bethlehem.

The Babe in the crib is placed in a setting of columns that was inspired by the Temple of Castor and Pollux in the Roman Forum, and is meant to signify the triumph of Christianity over paganism. Set in the Museum's Medieval Sculpture Hall, in front of the Spanish screen from the Cathedral of Valladolid, the crèche and the angel-encrusted tree create an exhilarating scene of life and joy.

The tradition of re-creating the events at the manger is an ancient one that reached a crescendo in eighteenth-century Naples. Leading artists of the day were commissioned by noble families to translate depictions created for the churches to smaller versions suitable for enjoyment at home. The idea of humanizing the Christmas miracle in a domestic setting rapidly grew from just the three figures of Mary, Joseph, and the Child into extravagant panoramas containing hundreds of figures.

Theatrical backgrounds of rustic landscapes were filled with characters from the Bible story: the Holy Family, the animals at the manger, the shepherds and their flocks, the magi. Soon the *presepio*, as such an assemblage was called in Naples, expanded to include representations of classical architecture, Neapolitan tradespeople, and the exotic travelers who found their way to the city. Choirs of angels presided over all.

Neapolitan crèches were arranged with the verve and abandon so often found in art of the Baroque period. Many of the figures were portraits of the townspeople, shown dressed in current fashion and attending to their trades. This realism popularized the story of the Nativity to such an extent that collecting crèche figures became a national passion. The artists who created the figures and the designers who devised the settings were stars rich with commissions. Noted architects such as Francesco Cappello, Muzio Nauclerio, and Nicola Taglicozzi Canale were enlisted to guide the elaborate productions.

Sculpture, after a period of some neglect, flourished in eighteenth-century Naples, encouraging a growing number of skilled artists. They produced life-size, three-dimensional figures of religious and mythological subjects as well as portraits of important patrons. The works of such sculptors as Matteo Bottigliero, Francesco Celebrano, Salvatore di Franco, and the prolific and noted Giuseppe Sanmartino (also known as Sammartino) filled the churches and palaces.

When the reigning kings and other people in power turned their attention to assembling their own collections of small crèche figures, they demanded the same perfection in the miniatures as they found in the life-size figures in ecclesiastical settings. Many of Naples' most acclaimed sculptors turned their talents to creating the small figures that are now so

highly prized because of their beauty and because they are examples of the work of masters.

The idea of celebrating the Nativity in three-dimensional form is rich in legends. One is of Saint Francis of Assisi, who created a Bethlehem at midnight mass in Greccio in 1223. It is said he arranged a child on a bed of straw with an ox, an ass, and a lamb to evoke the manger. When Saint Francis lifted the child, he woke and seemed to bless the congregation. Even though the presence of a child is disputed, the story is a touching one and is often used in discussing the development of the Christmas crèche, in which Saint Francis played an important part. In 1210, Pope Innocent III had condemned liturgical dramas in churches, feeling

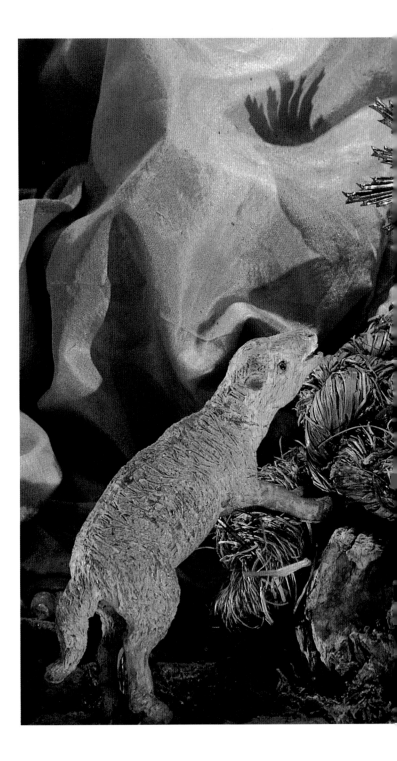

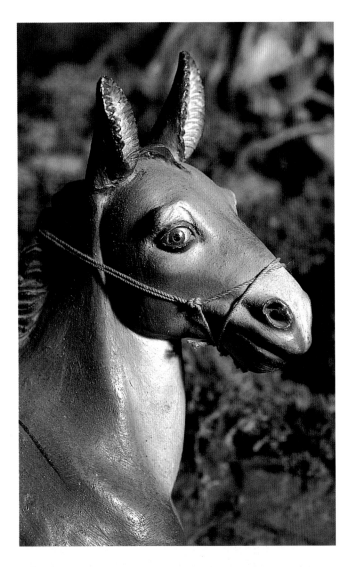

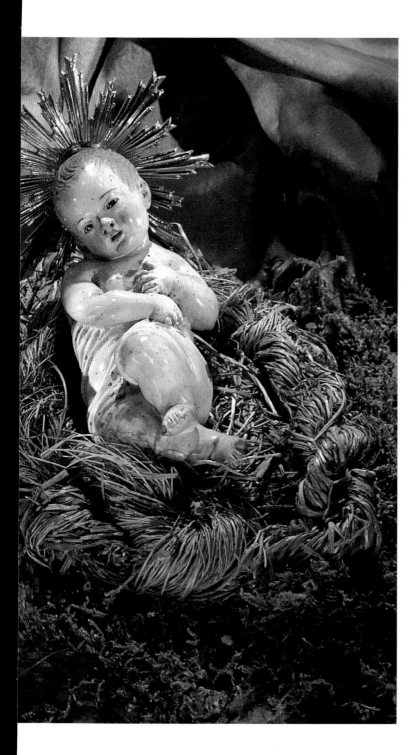

that their number and variety had gotten out of hand. It was Saint Francis who asked the Pope's permission to set up his *presepio* in Greccio, and so breathed new life into an ancient idea.

The eminent art historian Dr. Rudolf Berliner, who extensively researched the subject, wrote:

> The first Christmas crèche known to have been erected in a church stood, not in a Franciscan church, but in the Jesuit church in Prague in 1562. It was a realistic representation of the Nativity, and was constructed especially and exclusively for the Christmas season. . . .
>
> Although not an ancient church custom at that time, the erection of crèches grew from an ancient spiritual exercise. Church Fathers had

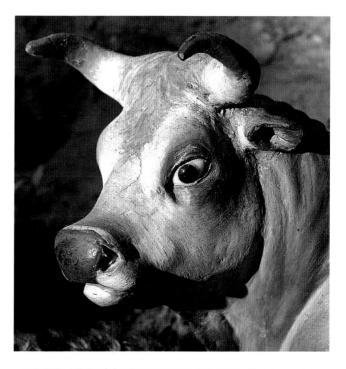

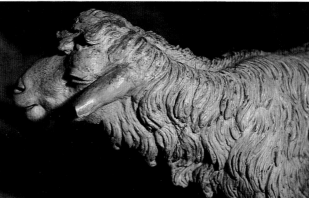

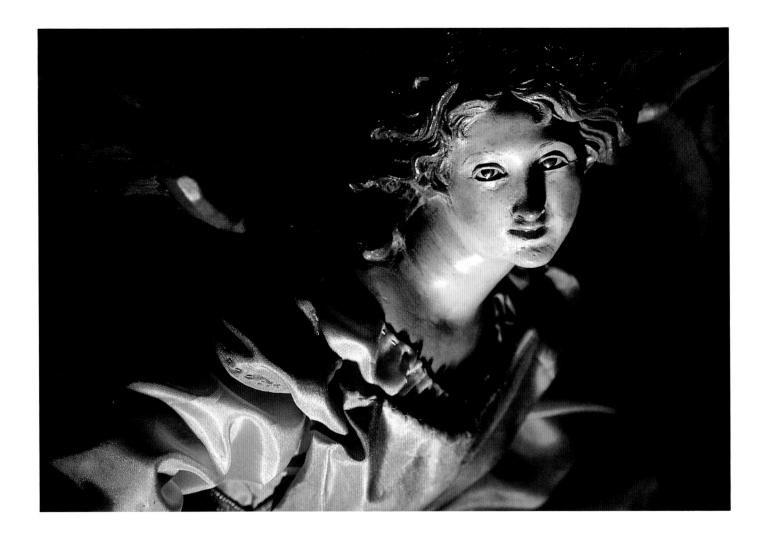

interpreted the words of the Angel to the shepherds, "Go unto Bethlehem" (Luke 2:12) and the words of the shepherds "Let us go unto Bethlehem" (Luke 2:15) as a summons to all believers to come and participate in the Christmas ceremony. Thus when the faithful attended Christmas mass, they were to feel that they were making a spiritual pilgrimage with those very shepherds unto Bethlehem. ["The Origin of the Crèche," *Gazette des Beaux-Arts,* October–November, 1946]

The Jesuits did adopt the crèche as a special Christmas devotion and took it with them on their ministries throughout the world. In 1642, a Jesuit missionary in Canada wrote that their Christmas crèches were a great success with the American Indians.

The representation of the Nativity as part of religious practice and as an art form has a long history. According to legend, the early Christians brought wood from the the actual crib to Rome for a reliquary. The very realistic Christmas crèches of Naples were predated by depictions of the Holy Family and the manger scene in paintings, mosaics, ceramics, stone, wood, and the most precious of metals and jewels. According to Dr. Berliner:

During the Middle Ages *presepe* also designated a reconstruction of the place of the Nativity. The first reconstruction, known to us, stood in Rome in the precincts of the Liberian Basilica, which was consequently called S. Maria ad Praesepe. This name is definitely attested under Pope

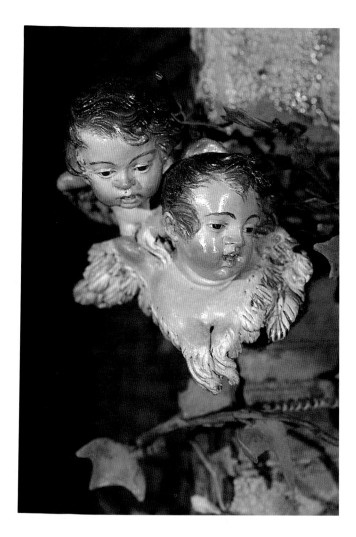

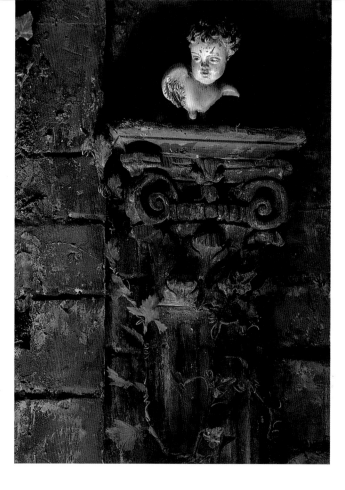

Theodore (642–649), but it is probable that it was used even as early as 550. [It is now the church of Sta. Maria Maggiore] . . . A century after the first mention of the *Presepe* in S. Maria Maggiore, Gregory III (731–746) donated to the chapel a golden statue of Mary embracing the Child. It most probably stood upon the altar within which, presumably, relics from the rock of the cave were already housed.

A stone Adoration scene by Arnolfo di Cambio was placed in a niche near this small room in 1291.

After 1311 there were polychrome wood carvings of the Nativity in the nunnery of Sta. Chiara in Naples. And, in 1344, Margaretha Ebner, a Dominican nun, wrote in her "Revelations" that she received from Vienna a Christ Child in a

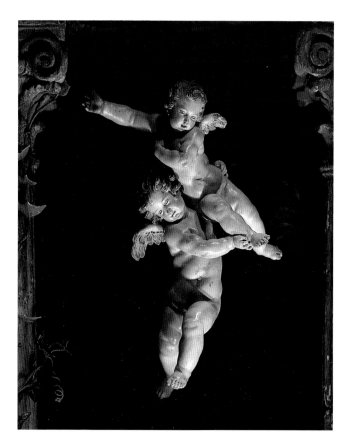

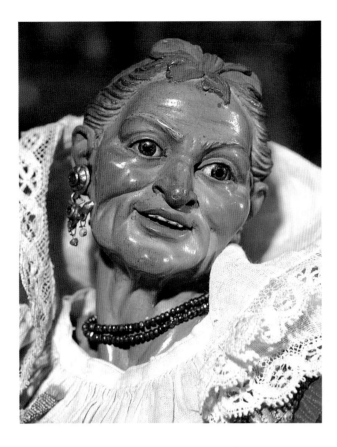

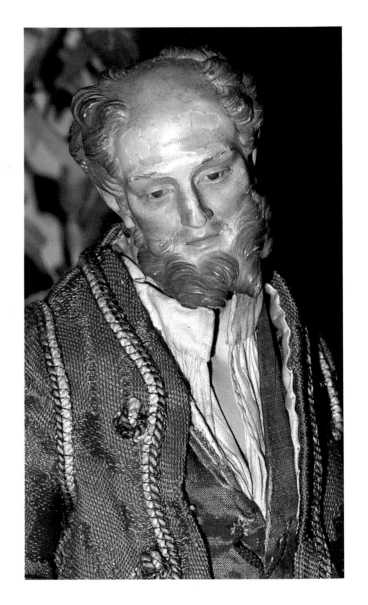

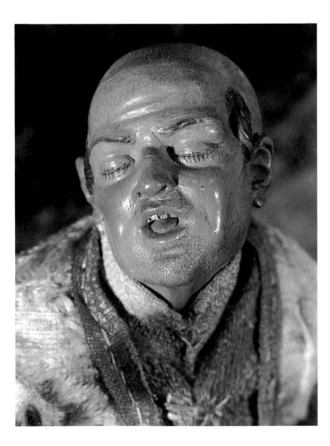

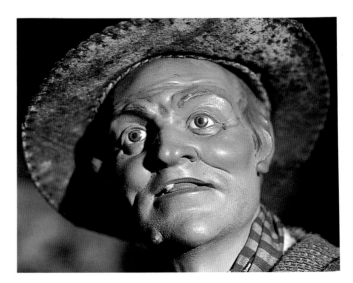

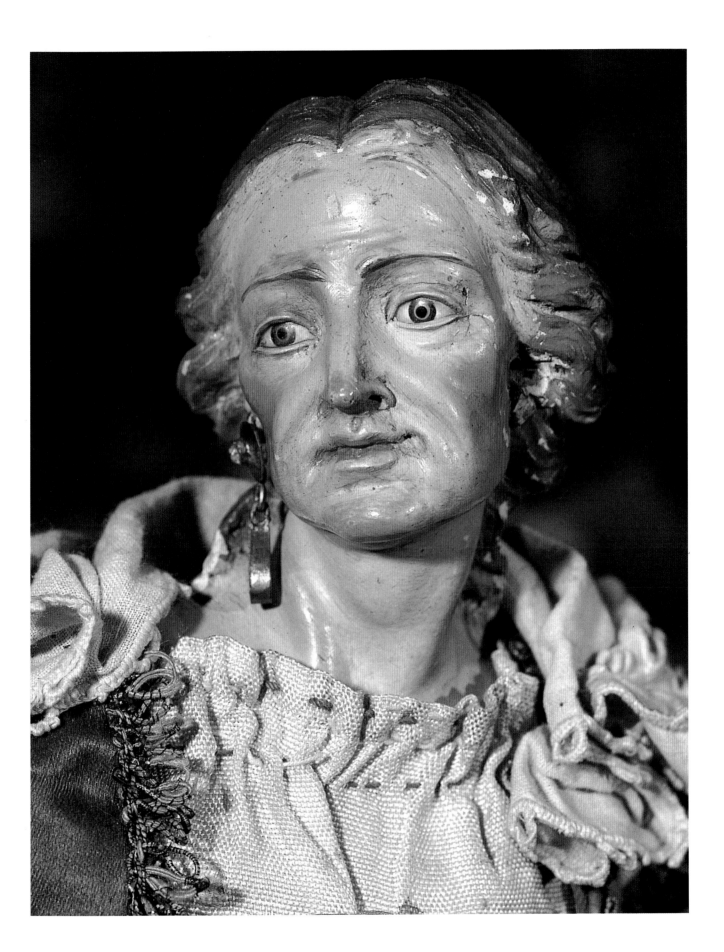

cradle with four little golden angels. A reliquary Bethlehem of gold, enamel, and jewels was presented by the Bishop of Burgundy to his cathedral in Utrecht in 1489. Jewels reflected on the ceiling of the golden stable, representing the heavenly light.

The famed Florentine architect Bernardo Buontalenti built a mechanical Bethlehem in about 1560 for his pupil Francesco de Medici. Sophia of Saxony gave a similar one to her Protestant husband, Christian I, in 1588. Dr. Berliner describes it in this way:

> The mechanism of this gift had been made by an Augsburgian watchmaker, Hans Schlottheim (1547–1625). Both these mechanical Bethlehems were extremely complicated, with much emphasis laid upon representation of the Heavens. The Schlottheim Bethlehem stands about three feet high. The base is a large drum which is entirely decorated with silversmith work, the subject matter of which stresses man's sins and salvation. Atop the drum is a stage, the players being mechanical figures not more than a few inches high. From the stage rise brackets which support a globe, from which in turn rises the Tower of Babel—perhaps a final Protestant emphasis upon the Sin of Man. A clockwork controls the complicated activity within this object. The globe opens, revealing God the Father who raises his hand in blessing. Three angels fly downward to the stage region, while a Christmas song issues forth. When they have again ascended, the globe closes, and a procession of adoring figures (kings, shepherds, etc.) are conveyed on a mechanical device round and round the Nativity figures which are in an open-faced house in the center of the stage. When the Adoration procession is finished, Joseph rocks the cradle, accompanied by a cradle song.

Through the ages, simple and elaborate representations of the Nativity were used for devotion during the year. In the sixteenth century there was a new development, which has been attributed to the Duchess of Amalfi. She assembled a large number of articulated figures to display specifically during the holy Christmas season. (Her household inventory of 1567 included some 116 figures, among them angels, animals, and a virgin with a unicorn.) Each year they were taken from two great storage chests and arranged as an ever-changing theatrical spectacle. Then the idea of articulated crèche figures began to spread to other regions. In 1580, a Bavarian princess wrote to her brother in Munich asking for such figures dressed like "fine dolls." By 1734, when Don Carlos of Bourbon became King of Naples, the making and displaying of these small figures was a full-blown pursuit among Neapolitans. It is recorded that the king's own collection numbered almost 6,000 figures.

The royal court of Ferdinando IV, who acceded to the Neapolitan throne in 1759, delighted in the creation of its Christmas crèche. King Ferdinando made some of the figures, and Queen Maria Carolina and her ladies dressed the angels, magi, and exotic travelers in fashionable clothes. They used lavish silks, often from the famous silk makers near Caserta. Brocades, ribbons, and laces were woven with tiny patterns to suit the small figures. Trimmings and accessories were exquisite. Jewelry in miniature scale was designed and made of precious metals and stones by famous goldsmiths in Genoa and North Africa. The tradespeople from the town and the shepherds from the countryside were dressed with the same care in appropriate homespuns, embroideries, leathers, and sheepskins. They were shown with their wares displayed in tiny baskets or on stands or stalls: miniature hand-blown glass objects for the table, ceramics, copper pots and pans, infinite varieties of fruits, vegetables, and local cheeses in wax or terra cotta. Vignettes of Neapolitan life were made as real as possible.

Nesta de Robeck, in her book *The Christmas Presepio in Italy* (Florence, 1934), paints a lively picture of *presepio* fervor in the eighteenth century:

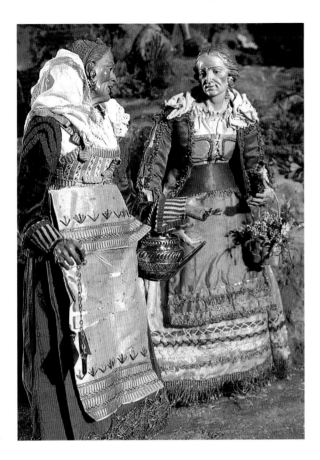

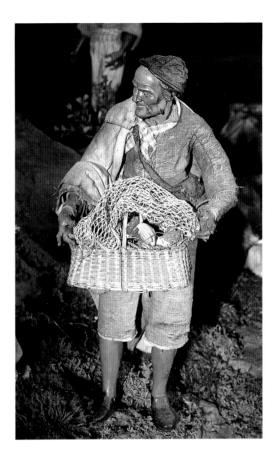

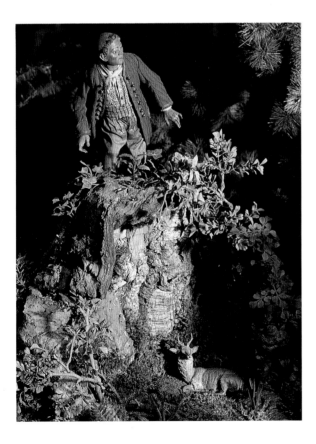

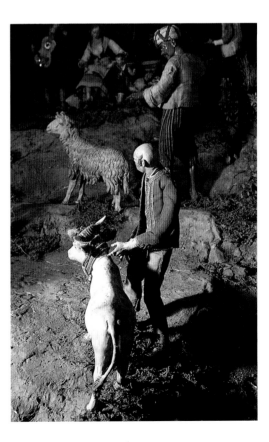

It is said that four hundred Neapolitain [sic] churches annually set up their Presepio and many private houses too had their own "Bethlehem" on which the owners spent vast sums of money encouraged to do so by a famous preacher Padre Rocco who made the Presepio his particular object of devotion. His influence was enormous. . . . Advent was spent in a frenzy of preparation and Christmas became a social event with people rushing from house to house, church to church, visiting, admiring, criticising each others Bethlehem. Often the Presepio occupied the whole floor of a house, sometimes even the whole house, different scenes being represented in different rooms and concerts of appropriate Nativity music held in honour of any distinguished guest.

Samuel Sharp, a British surgeon and visitor to Naples during this period, recorded in his *Letters from Italy* (London, 1766): "What renders a Presepio really an object of a man of taste, is the artful disposition of the figures, amidst scenery of perspective, most wonderfully deceitful to the eye. A certain merchant has one on the top of his house, where the perspective is so well preserved, that, by being open at one end, the distant country and mountains become a continuity of the Presepio, and seem really to be a part of it."

As a young man in the 1950s, William H. Luers, now President of the Metropolitan Museum, lived in Naples for four years. He speaks of it with particular pleasure: "Naples is the quintessential Mediterranean port city—a vessel into which Western civilization has poured some of its finest moments over the past 3,000 years. In Naples, the Greeks, Etruscans, Romans, Normans, Saracens, French, Hohenzollerns, Spaniards, and so many more have left the remains of conquest and culture.

"The language of Naples—that rich poetic spirit of the city itself—is perhaps the most lively reflection of this multicultured city. French and Arabic are mixed with Italian and Latin, with a very strong Spanish accent."

William Luers fell in love with the city, with its unique dialect, and with its customs. He remembers "some of the traditions that make up the harmony of Christmas time in Naples: Christmas in Napoli recalls 'bancarelle' (the wooden stalls in the streets), 'capitone' (the eel that is eaten at Christmas and is sold in the streets by singing vendors), the 'botte' (or firecrackers), the 'zamponari' (Abruzzi Hills shepherds with bagpipes who come to the town), and the 'presepio' (or crèche)."

Each December he walked the old streets of Naples, visiting church after church to see "the magnificent *presepi*, each one more touching, more lovely than the last. The sounds, smells, and sights vibrate in a rhythm with the dialect, and make a unique and lovely work of art—Naples at Christmas."

Standing in front of the Angel Tree at the Metropolitan Museum, William Luers remembers "the illustrious Neapolitan poet Salvatore di Giacomo, whose poem "Nuttata e Natale" was written in Neapolitan dialect:

Ahimè! L'Amore è comm e na muntagna
e ce sta 'ncoppa n'arbero affatato

Ah me, love is like a mountain
And on top grows a magic tree

The tree at the Metropolitan Museum, resplendent with eighteenth-century Neapolitan crèche figures, evokes the mirth and magic of Christmas in Naples. The majority of the figures are from the famous collection called "The Adoration of Angels." In 1952, the "Adoration" was exhibited in Paris and was seen by Francis Henry Taylor, then director of the Museum. He brought it to the attention of Loretta Hines Howard, a friend of the museum and an avid collector of crèches. The owner was Eugenio Catello, whose family museum of *presepio* art in Naples is world-famous. After much correspondence, the purchase of the "Adoration" was arranged.

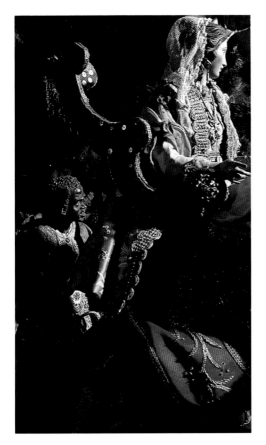

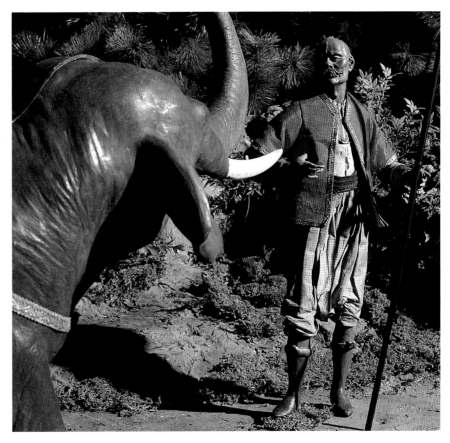

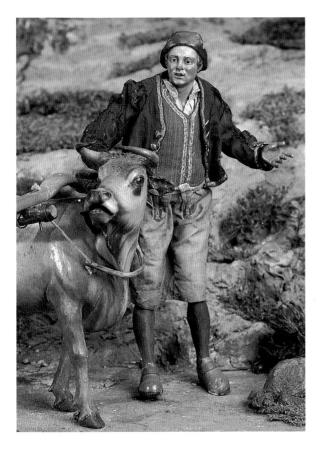

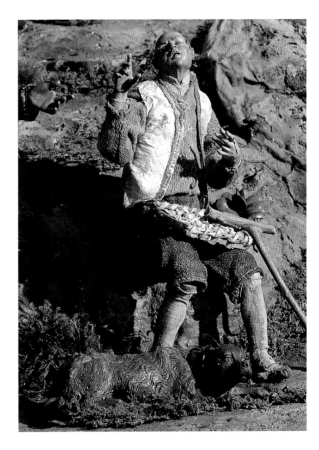

69

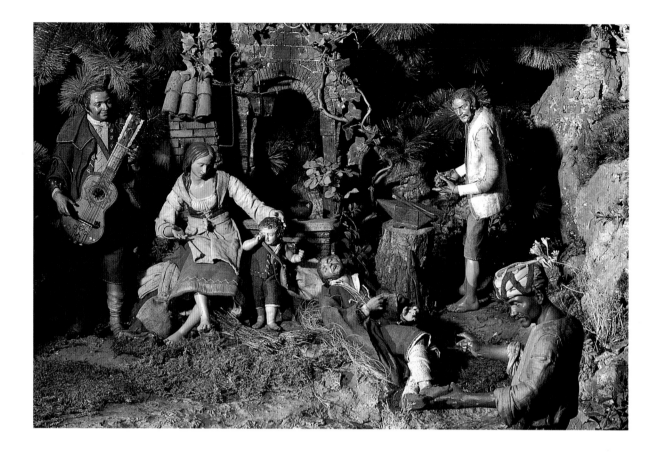

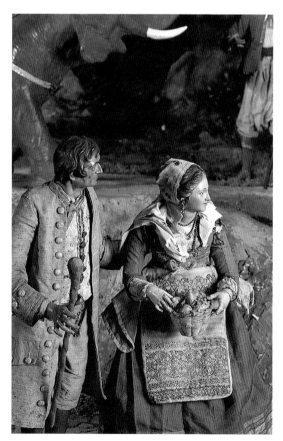

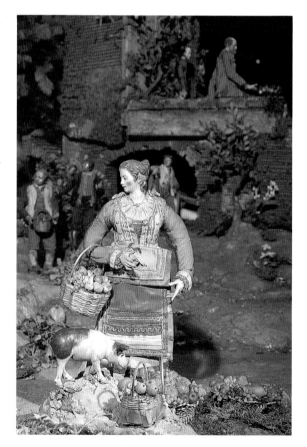

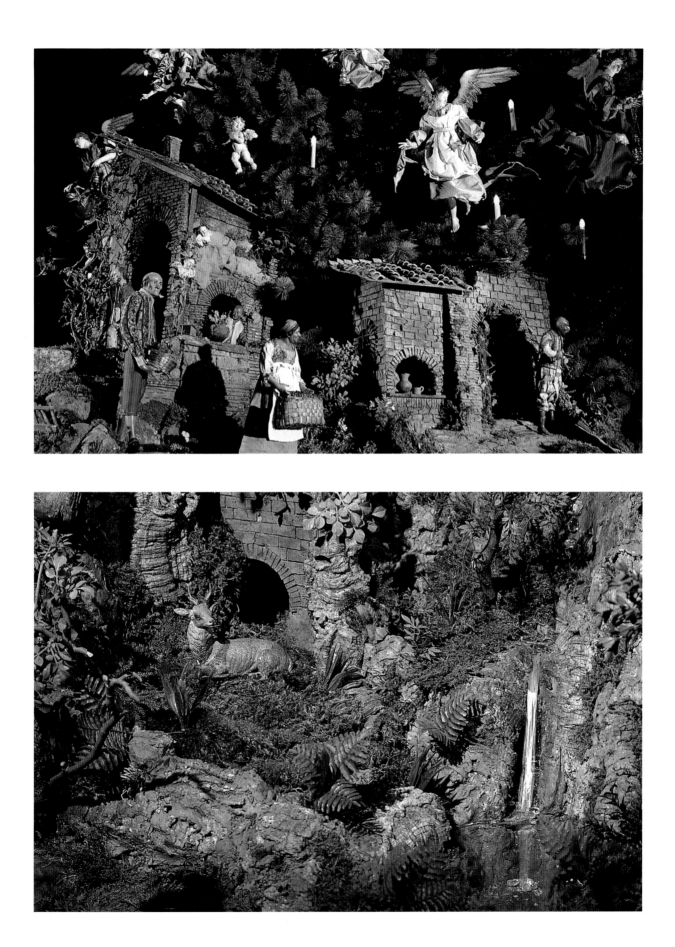

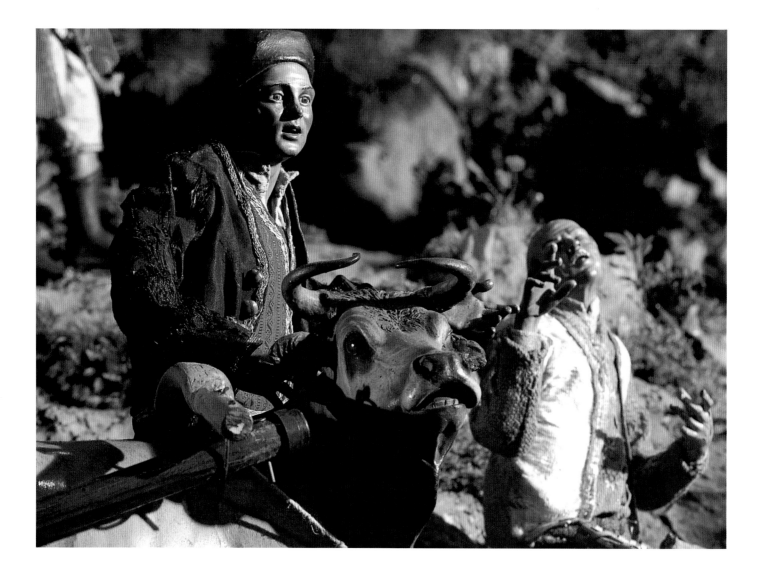

Through their letters, Loretta Howard and Eugenio Catello became friends, and she made a trip to Naples to see him. In an interview she told of her visit:

I was met by an interpreter, as I spoke no Italian. He took me to Mr. Catello's house, where I was greeted by two very serious young men and a lovely young woman, all in deep mourning. They told me they were Mr. Catello's children and that he had just died. I was very shocked and quite spontaneously asked what had caused his death. They told me, "Joy!" I thought there must be some misunderstanding in the language, so I asked how that could be, and they told me this tale. Some years before, Mr. Catello's father

had sold a magnificent crèche to the artist [José] Sert. Mr. Catello heard that Sert was dead, so he wrote to his widow in Paris to see if he could buy back the crèche. He never heard from her and then found out that she, too, had died. He was determined to locate the crèche. With the greatest difficulty, he finally found it and discovered it was in perfect condition as it had never been unpacked. He was so overcome with joy, he died.

The "Adoration" arrived from Italy just in time for Christmas of 1955. As it came without a traditional architectural landscape, Loretta Howard arranged the figures in the branches of the family Christmas tree,

with the angels soaring to a star of lights at the top. The result was greatly admired, and she was asked by James J. Rorimer, the new director of the Metropolitan, to re-create her angel tree in the Great Hall of the Museum in 1957 and 1958. After similar exhibitions at the Albright Gallery in Buffalo in 1962 and 1963, and at the Detroit Institute of Art in 1964, she gave her crèche to the Metropolitan for its permanent collection. In 1965, the first of the very special Christmas exhibitions was arranged. Loretta Howard's idea of combining the Neapolitan crèche figures with the traditional Northern European Christmas tree, and bathing the spectacle with glowing lights and joyous music, created an artistic expression of great beauty.

Shortly after the acquisition, Olga Raggio, Chairman of the Department of European Sculpture and Decorative Arts at the Museum, wrote in an article about the collection:

By far the largest group of figures in the Howard crèche is made up of a host of delightfully dimpled cherubs, delicately modeled like biscuit figurines, and some fifty large and elegant angels. These, clad in swirling pastel draperies, their hair knotted by a mystical wind, their cheeks flustered by a sweet celestial emotion, are seen swinging their finely chased silver-gilt censers or suspended in adoration. Did these heavenly creatures once belong perhaps to a famous crib set up every Christmas, until 1826, by the De Giorgio family, which had an extraordinary Glory of angels that the people flocked to admire? We will never know for sure.

Stylistic comparisons with many signed figures in the collections of Naples, and in a documented crèche in the Bavarian National Museum in Munich, suggest that about half of the Howard angels should be credited to the best late-eighteenth-century masters: Giuseppe Sammartino (1720–1793), well known for his monumental sculptures in marble and in stucco; his pupils Salvatore di Franco, Giuseppe Gori, and Angelo Viva, and one Lorenzo Mosca (d. 1789), who was employed at the Royal Porcelain

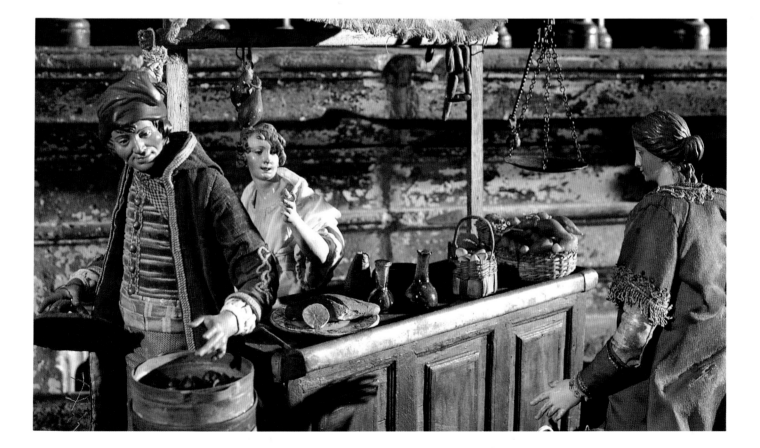

Factory at Capodimonte and as stage director of the royal Christmas Crib.

In the central group of The Holy Family—the *Mistero*, as Neapolitans used to call it—the noble and tender figures of Mary, Joseph, and the Babe lying in a manger are also modeled and carved with exquisite care. They are attributed to Salvatore di Franco, who is mentioned by contemporary sources as one of the best *presepio* sculptors of the time. Next are the three Magi, splendidly attired in long cloaks of silk embroidered with silver, gold, and sequins, topped with simulated ermine capes, their costume perhaps inspired by the colorful garb worn by the Knights of San Gennaro on the yearly festival in Naples. They approach the Divine Infant with expressions of tender awe and piety, marvel or mystical expectation, gesturing with their delicate, nervous hands.

Behind the Magi came the mingled crowd of brightly dressed, exotic travelers, who symbolized the homage rendered by all nations to the Divine Child: there are Mongols and Moors mingled with Turks and Circassians, advancing on horseback or on foot, carrying their colorful trappings, banners, and lances, followed by their camels, attendants, and dogs. It is in this section of the *presepio* that the imagination of patrons and artists, free from literal fidelity to the Scriptures, fascinated by exotic costumes and types, gave itself full rein and indulged in the wildest flights, in a vein that reminds us of the *Turqueries* and eighteenth-century opera and ballet rather than sacred drama. To these figures belong some of the most elaborate accessories: finely chased and gilded scimitars and daggers, silver baskets, and purses, all miniature masterpieces executed by Neapolitan silversmiths and other specialized craftsmen.

A sure theatrical instinct presided over the creation of a Neapolitan Christmas crèche. The world of the exotic was counterbalanced by the more homely world of humble shepherds and simple folk, who act out their emotions and speak the

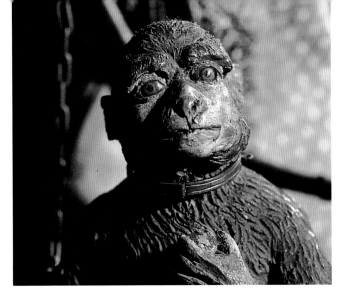

language of the heart. We see some of the shepherds, clad in rough sheepskin clothes, awakened from their sleep by the Angel of the Lord, dazzled by the light that suddenly breaks through the night, or bemused by the celestial music that fills the heavens, their faces reflecting their feelings with pulsating vitality and truth. Nothing is conventional here, and the eighteenth century has hardly left us more lively and natural portraits than these. Academically trained artists, sometimes well known as porcelain-modelers—like Francesco Celebrano, to whom, among others, figures like these are often attributed—have abandoned here the formulas of "great art" in an effort to achieve Christmas crib figures. A humorous, realistic note is struck by the sheep and goats. Skillfully modeled in terra cotta, they are for the most part attributed to Saverio Vassallo, one of the best Neapolitan *animaliers* of the day.

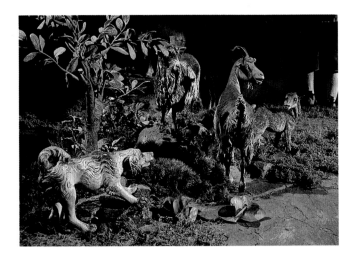

The same naturalistic vein appears in the figures of people in the inn of Bethlehem. Here are rich burghers, merchants, or valets, some of which seem to be individual portraits of exhilarating realism; peasants in gay attire of the islands of Ischia and Procida; or women coming from the countryside to peddle their produce, colorfully displayed in miniature baskets. All of them are potential actors of little genre scenes to be spontaneously set into action and made to relate to one another, in chatter or in laughter, under the sharp limelight of the stage, like the characters of a miniature *commedia dell'arte*.

The magic of the theater and the warmth of simple, sincere emotions are still today the most endearing qualities of a Neapolitan crèche.

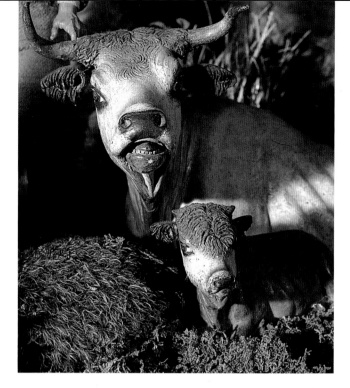

At the Metropolitan Museum in mid November, there is a ripple of excitement when the center of the Medieval Sculpture Hall is partially closed off with gray work screens. Staff and visitors know that this is the beginning of the installation of the Christmas tree, and they plan their walks to watch its progress. Surprisingly enough, it starts from the top. A thirty-foot pole is inserted into a sculpted wooden base that has been put together like a giant jigsaw puzzle. The highest part goes up first, starting with the brilliant star designed by artist Enrique Espinoza. The tree grows down instead of up, branch by branch, angel by angel, until it reaches its fullest point and is surrounded by a sculptured landscape and architectural elements. The crèche figures are arranged in a composition that changes from year to year as figures are added and the setting redesigned to accommodate them. Tiny handmade silk plants and flowers, real moss and rocks with real lichen are added. The lighting is refined, the music rehearsed, and all is made ready for the opening night.

One evening in early December, friends gather for the first lighting. In the darkness of the Medieval Hall, to the beginning strains of "Silent Night," moonlight bathes the Babe in his crib. A

play of light reveals the Holy Family and the nearest, encircling angels. Very subtly you become aware of the host of angels ascending to the heavens. Candles begin to glow, lighting their faces. The top star catches the brilliance, and as "Joy to the World" is heralded, the landscape, the pilgrims, and their retinues are illuminated in a burst of light.

There is a hush over the audience in a private moment of wonder and awe, then spontaneous jubilation at this scene of peace and renewal, this scene of Christmas and the celebration of family.

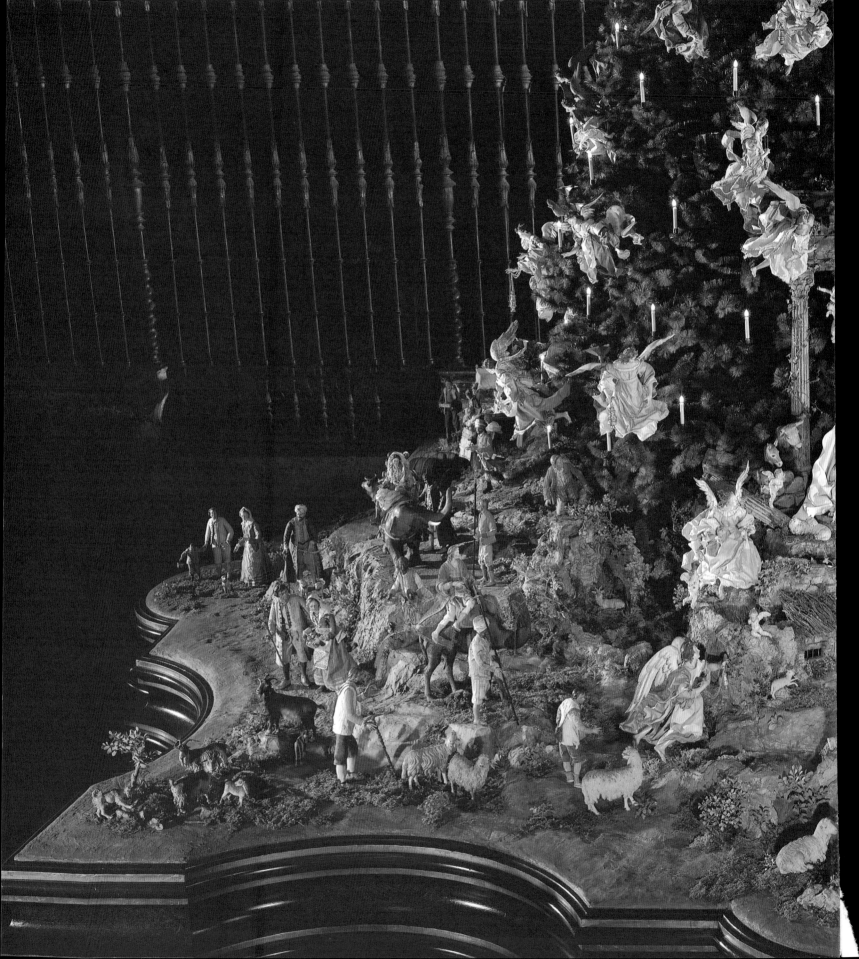

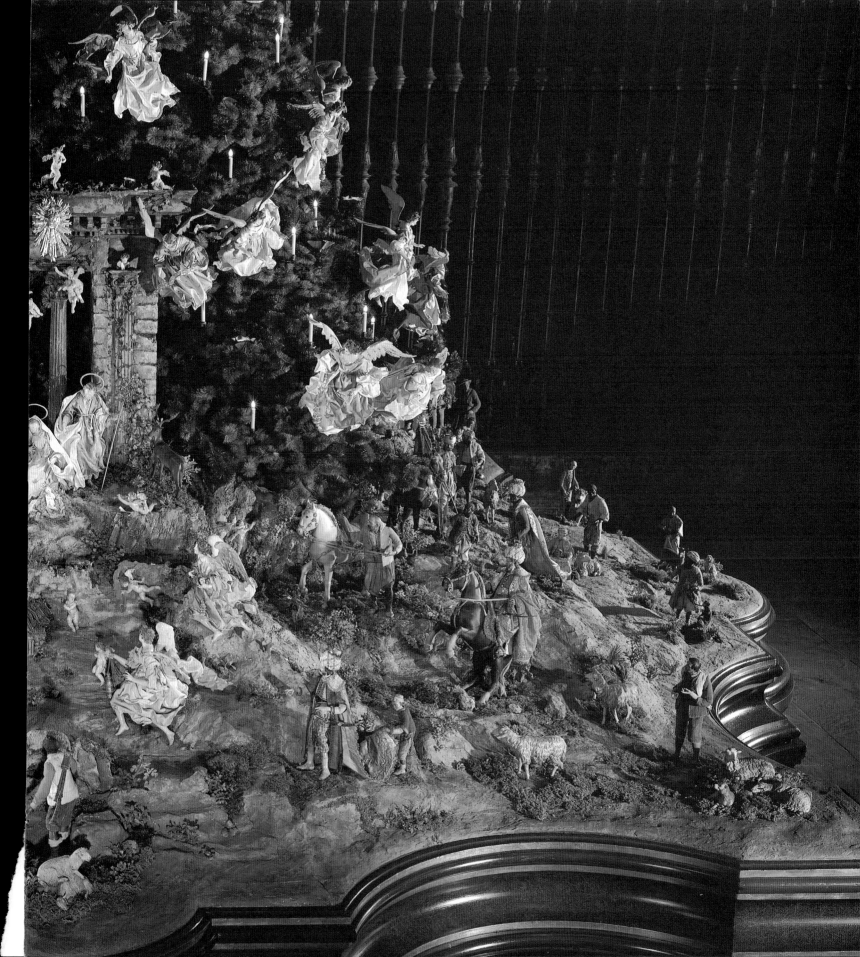

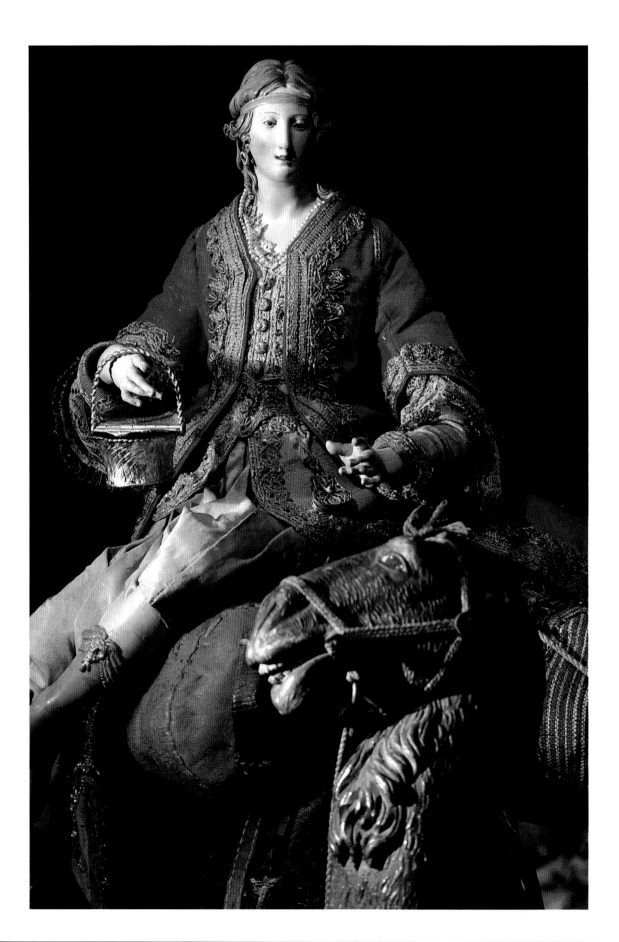

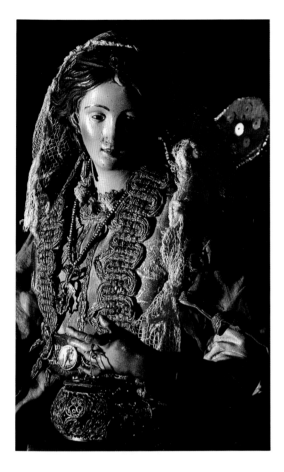

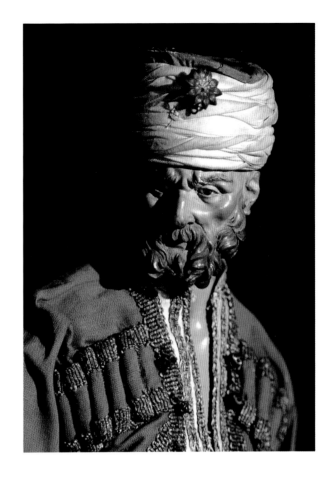

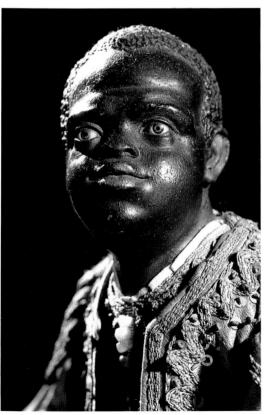

Glossary

Animaliers: Neapolitan artists who created animal sculptures for the crèches.

Bethlehems: Nativity scenes, often presented in a framed case.

Christmas: "Christ's Mass," a celebration commemorating the birth of Christ.

Crèche: Now a universal term, is a French word from the low Latin *cripia*, which means crib, a depiction of the scene at the manger.

Crib: The Nativity scene at the manger.

Mistero: An intimate grouping of the Holy Family.

Nativity: A representation of the birth of Christ.

Presepio, presepe: A Neapolitan crèche, a crib, the manger of Christ, a realistic depiction of the Nativity.

The Care of the Figures

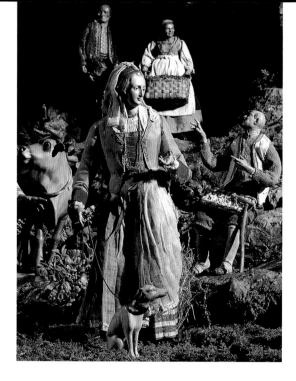

After the Feast of the Epiphany on January 6, the Angel Tree is dismantled and each figure is dusted with a sable brush. It is then throughly examined before being placed in one of the cases, where the figures are held in specially constructed supports, to be stored in a temperature-controlled environment until the next Christmas season. Any work that is needed to further preserve a figure is approached with the careful consideration accorded the conservation of all art in the Museum.

For example, some discoloration was found on the lace-trimmed mantle of one of the elaborately dressed women. She was sent to the conservation laboratory of the Museum's Costume Institute, where she was photographed from all angles, handled by a conservator wearing white cotton gloves. The mantle was removed and a paper pattern made, fold for fold, so that the original could be refolded exactly. More photographs were then taken, this time with a special camera attached to a microscope, and a minute specimen of fiber was analyzed to see if the stain removal should be attempted. The decision was to try a water method. The tiny mantle was taken to the washing table, where non-ionic detergent and deionized water were gently applied. It was then put on the drying table and very lightly finger-pressed and refolded. Had it been decided that the fabric could not tolerate a water washing, it would probably have been dusted with a very absorbent powder and vacuumed with an aspirator to withdraw the stain.

If the figure's terra-cotta head or wooden hands and feet had needed attention, it would have been sent to Objects Conservation. A broken finger or hand would be seen by a wood specialist, who might find that hide glue would be enough to rejoin the pieces—a repair that could be reversed at a later date if necessary. If the pieces needed more support, a tiny pin might be inserted. If paint was

flaking, a sample would be viewed in a scanning electron microscope, which magnifies up to 400,000 times. An attachment, the energy-dispersive X-ray spectrometer, would determine its elemental composition. Then a decision would be made on how to restore its patination.

In the eighteenth century, after the little head was sculpted and fired, it was covered with a white gesso, polychromed with tempera, and polished to a high sheen. To restore this effect might be a matter of injecting gelatin between the terra cotta and the raised gesso, then lightly pressing the gesso back into place. If there was a greater loss, it would be isolated with a synthetic resin so that the fill could be removed later at the discretion of a future curator and conservator. The new white gesso fill, a mixture of whiting, hide glue, and water, similar to the recipe used in the eighteenth century, would be polychromed with a gouache pigment and varnished with a synthetic resin to duplicate the luster.

This meshing of science and art gives the conservator firm data that takes some of the guesswork out of decision-making. Together with the technical information, the eye, the hand, and human judgment tell the conservator just how far to go.

Artists and Attributions

Matteo Bottigliero (1684–1757)

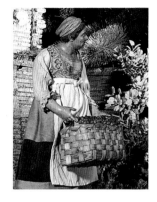

As a young man Bottigliero worked in the shop of Lorenzo Vaccaro. He and Lorenzo's son Domenico are considered the leading sculptors in Naples during the first half of the eighteenth century. Bottigliero's work can be seen in churches and monasteries including the Monastero di S. Gregorio Armeno, the Chiesa del Gesù Nuovo, and the Chiesa del Carmine. The silver statue of S. Andrew the Apostle in the Amalfi Cathedral was made to his design. Figures in some of the most renowned *presepi* in Naples and the peasant woman with a basket of grapes *(above)* in the Howard crèche are attributed to him.

Francesco Celebrano (1729–1814)

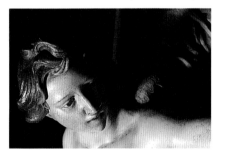

Celebrano was a painter and sculptor with many commissions and appointments from Ferdinando IV, among them Painter to the Royal Chamber and Tutor of the Duke of Calabria. It was recorded in 1772 that he was an expert modeler at the Portici porcelain factory. He is most known for the high-relief marble of the *Deposition* (1776) and the Sepulcher of Cecco di Sangro in the Sansevero Chapel in Naples. In 1800 he assembled and installed a large crib in Palermo, where the Bourbon court spent the Christmas season. A completely sculpted terra-cotta angel *(above)* in the Howard crèche is attributed to him.

Salvatore di Franco (late 18th and 19th centuries)

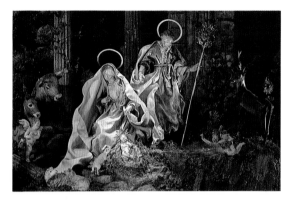

Considered one of Giuseppe Sanmartino's most imaginative pupils, Di Franco's sculpture may be seen in a number of churches in Naples: the Sepulcher of Giovanni Assenzio de Goyzueta in the Chiesa della Nunziatella and S. Benedetto in the Chiesa dell'Eremo dei Camaldoli are two of his most monumental works. He is known for the realism of his faces and figures. Seven of the figures in the Howard crèche are attributed to him: the Virgin and Saint Joseph *(above)*, and five angels *(see pages 4; 5; 31 and 36–37; 50).*

Francesco Gallo (late 18th and 19th centuries)

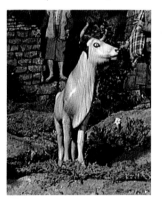

Old inventories of *presepi* list Francesco Gallo as a maker of animals, and it is known that he was a modeler at the Royal Porcelain Factory in Palermo in 1788. Records show that he used animals in the Royal Zoo in Naples as inspiration, including the elephant that arrived with the Turkish Embassy. In 1804 he modeled two dogs for the Heir Apparent. The Howard collection contains two sheep *(see page 82 right, middle)* attributed to the artist and a finely sculpted young bull *(above)* with GALLO inscribed on the underbelly.

Giuseppe Gori (late 18th and 19th centuries)

Nicola Ingaldi (late 18th and 19th centuries)

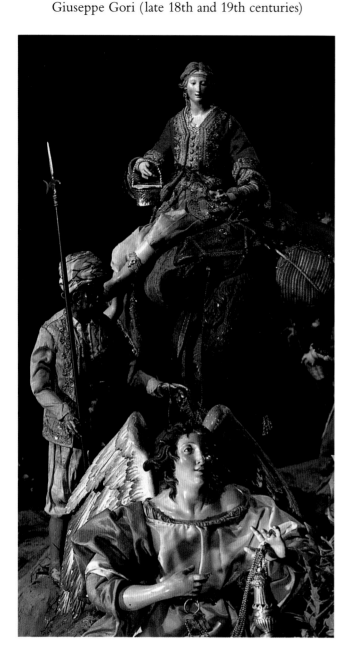

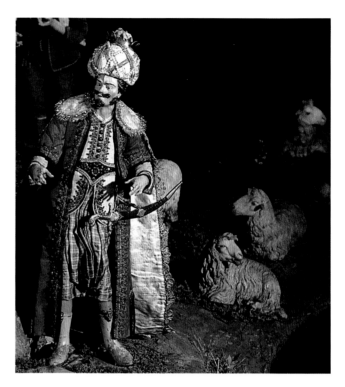

Ingaldi was a man of various skills. In 1862, his statue of the Blessed Virgin was inaugurated in the old Chiesa del Gesù in the presence of royalty. Along with several members of his family, he was a modeler of numerous *presepio* figures. His shepherds and animals appear in the inventories of Francesco I and Ferdinando II, and State archives show that he applied for a position in the Royal Porcelain Factory. His work was strongly influenced by that of Giuseppe Sanmartino and Giuseppe Gori. A king *(above)* and an angel in the Howard crèche are attributed to Ingaldi.

Lorenzo Mosca (d. 1789)

Described as a *dilettante* who became a sculptor, Lorenzo Mosca "directed" cribs for many years, including one for the De Giorgio family. It has been suggested that a number of the figures in the Howard crèche may have come from the De Giorgio collection. To meet the great demand for his work, he used plaster casts, taking care to see that each piece was well finished and painted. He liked to dress families of figures in the costumes of nearby regions: Abruzzo, Calabria, Procida, and Torre del Greco. The Howard crèche contains three angels *(at left, foreground; see also pages 28–29 and 49; 34)*, a shepherd *(see pages 19 and 22, foreground)*, a man *(see page 64, bottom right)*, a woman *(see page 80)*, and a king's Oriental attendant *(see page 25, holding reins)* attributed to Mosca.

A pupil of Giuseppe Sanmartino, said to be one of his best disciples and very near in style to his master. Gori's work bridged the Baroque and Neoclassical periods. A variety of crèche figures range from sublime angels to country folk and exotic travelers. He often portrayed his patrons and their animals. In the Howard crèche there are five angels *(see pages 45 top, right; 48)*, one man, one king's Oriental attendant *(see foldout front, extreme left, in blue coat and turban)*, and a bejeweled lady on a camel *(above)* attributed to Gori.

Giovan Battista Polidoro (late 18th and 19th centuries)

Records show that Polidoro was a modeler in the Royal Porcelain Factory, and that in 1789 he asked to be relieved of his position because of ill health. It is also known that in 1801 he was paid for painting seventy-five figurines for the dessert service of the Royal Villa. In some cases his *presepio* figures are completely modeled in terra cotta. All are polychromed well. A king's Oriental attendant *(see opposite page left)* in the Howard crèche is attributed to Polidoro.

Giuseppe Sanmartino (1720–1793)

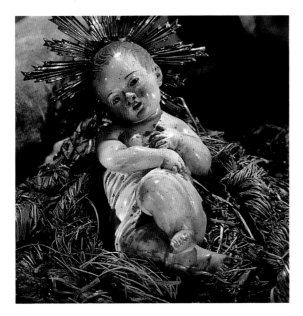

Prolific and talented, Giuseppe Sanmartino is considered the leading Neapolitan sculptor of the eighteenth century. His work can be seen in many churches in Naples and the surrounding region. The veiled Christ in the Sansevero Chapel in the Church of S. Ferdinando is considered his masterpiece. Some of the other churches rich with his Baroque figures and architectural decorations include: Certosa di S. Martino, S. Domenico Soriano, SS. Filippo e Giacomo, S. Giuseppe dei Ruffi. His interest in crib figures brought *presepio* art to a new height, and the fact that he devoted time to creating them is an indication of the importance of the *presepio* during that period. His modeling was particularly expressive and inspired a number of his pupils to copy his sense of realism. The following figures in the Howard crèche are attributed to Giuseppe Sanmartino: the Infant Jesus *(above)*, five angels *(see pages 38; 43; 55)*, two pairs of cherubs *(see pages 8 and 63 bottom)*, one king's Oriental attendant *(see page 79, right)*.

Nicola and Saverio Vassallo (18th and 19th centuries)

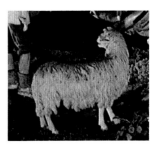

The Vassallo brothers, sons of the sculptor Onofrio Vassallo and pupils of Francesco di Nardo, were famous for their *presepio* figures of animals. They worked in terra cotta and wood, and often combined these and other materials. For example, in the Howard crèche the five sheep attributed to the Vassallos are a mixture: a terra-cotta body with lead legs and ears *(above and opposite page right, front)*; or, if the sheep is reclining, the ears may be carved of wood. It is known the Vassallos liked to work from life, and in one instance used the dogs from the pack of Ferdinando IV as models for figures commissioned for the elaborate Ruggiero crib.

Angelo Viva (1748–1837)

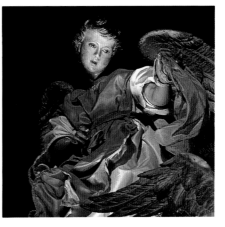

Like his teacher Giuseppe Sanmartino, Viva was a prolific sculptor in marble and terra cotta. His figures can be seen in the churches of S. Paolo Maggiore, the Nunziatella, and the Museo Nazionale de S. Martino. It is evident that his later work was influenced by the Neoclassical movement. Two figures in the Howard crèche are attributed to him: an angel completely sculpted in wood and plaster *(above)* and an articulated angel made of several materials.

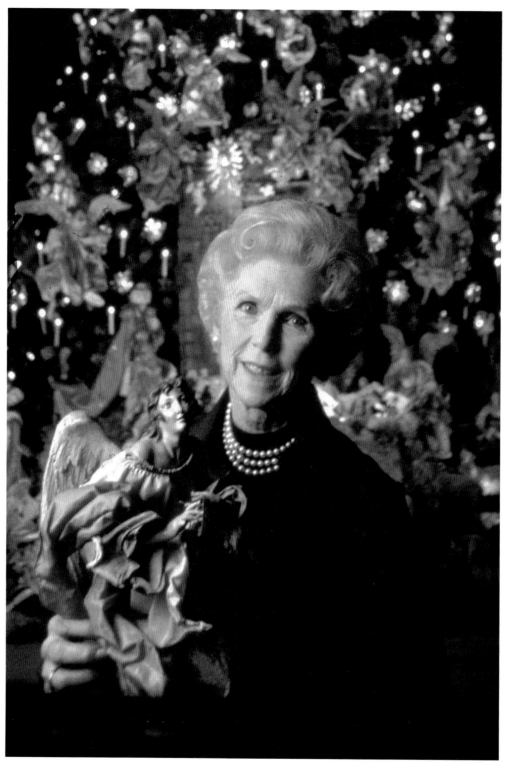

Photograph by Ernst Beadle

About the Collector

Loretta Hines Howard became interested in religious art during her childhood, when she visited museums and churches in Europe with her family. Just before her marriage to Howell Howard in 1924, she and her mother found three eighteenth-century Neapolitan crèche figures—Mary, Joseph, and the Babe—while shopping at Marshall Field's in Chicago for her new home in Dayton, Ohio. During her European honeymoon she looked for figures to add to the crèche and began the collecting that would become an important spiritual and artistic focus of her life.

Loretta Howard was a prolific painter who studied with Robert Henri. After her husband's death in 1937, she moved with their four children to New York, to be near the center of the art world. She continued to paint and her work was exhibited in gallery shows with recognition and success. Her home was filled with art and artists, especially at Christmas, when the house was elaborately decorated and her crèches displayed.

Through the years Loretta Howard searched for crèches to add to her collection and to give to family and friends. In 1957 she created the first Angel Tree at The Metropolitan Museum of Art. In 1962 she was invited by President and Mrs. Kennedy to arrange a crèche at the White House, and she continued to work with the White House through several administrations. In 1972 she gave a particularly splendid crèche to the Albright-Knox Art Gallery in Buffalo, New York, in memory of her friend Helen Northrup Knox.

After giving her crèche collection of some 150 figures to The Metropolitan Museum of Art for its permanent collection in 1964, Loretta Howard designed and installed yearly Christmas exhibitions until her death in 1982. It soon became a three-generation affair, with daughter Linn and grandchildren Andrea, Christopher, and Stephanie helping to create this most radiant scene celebrating Christmas. At a special lighting of the tree, a journalist asked Andrea what she liked best about the ceremony. She replied: "I like best to watch my grandmother's face. It is a face that lights up with the tree." The Howard family continues her work.

Bibliography

Art of the Presepio: The Neapolitan Crib of the Banco di Napoli Collection. Marisa Piccoli Catello (ed.). Essays by Raffaello Causa and Nicola Spinosa. Naples, 1987.

Berliner, Rudolf. "The Origins of the Crèche." *Gazette des beaux-arts*, October–November–December, 1946.

————. *Die Weihnachtskrippe.* Munich, 1955.

Bolz, Diane M. "Art Imitates Life in the Small World of Baroque Crèches." *Smithsonian Magazine,* December, 1991.

Borelli, Gennaro. *Il presepe napoletano.* Rome, 1970.

————. "Sanmartino, scultore per il presepe napoletano." Naples, 1966.

Castaldo, Giuseppe. "Christmas in Naples." *Italy Italy,* November 15–December 15, 1989.

Catello, Marisa Piccoli (ed.) See *Art of the Presepio: The Neapolitan Crib of the Banco di Napoli Collection.*

Causa, Raffaello. "Cinque secoli di presepe." *Civiltà della campania.* December, 1974.

————. "The Golden Age of the Neapolitan Presepio." See *Art of the Presepio: The Neapolitan Crib of the Banco di Napoli Collection.*

————. "Miracle Play." FMR, December, 1984.

————. "Napoli di Galilea." FMR, December, 1982.

————. "Il presepe cortese." *Civiltà del '700 a Napoli, 1734–1799.* Naples, n.d.

————. *Il presepe napoletano di Casa Leonetti.* Italy, n.d.

De Robeck, Nesta. *The Christmas Crib.* Milwaukee, 1956.

————. *The Christmas Presepio in Italy.* Florence, 1934.

De Vita, Oretta Zanni. "Gold, Frankincense, Myrrh and Maccaroni." *Italy Italy.* November 15–December 15, 1989.

Fidelfo, Margherita. "A Naples Crèche Goes to Pittsburgh." *Italy Italy*, November 15–December 15, 1989.

Fittipaldi, Teodoro. *Scultura napoletana del settecento.* Naples, 1980.

Fuhrimann, Klara von. "Neapolitanische Weihnachtskrippen." *Kulturelle Monatsschrift*, Christmas, 1965.

Mancini, Franco. *Il presepe napoletano nella collezione Eugenio Catello.* Naples, 1965.

————. *Il presepe napoletano: Scritte e testimonianze dal secolo XVIII al 1955.* Naples, 1983.

Miles, Joan. "A World Made in Miniature." *Italy Italy*, December, 1990.

Molajoli, B. *La scultura nel presepio napoletano del settecento.* Naples, 1950.

Perrone, Antonio. "Historic Notes on the Nativity Scene." Naples, 1896.

Presepio a San Martino. Exhibition catalogue. Naples, 1964.

Prisco, Michele. "Il presepe in provincia." *Civiltà della campania.* December, 1974.

Raggio, Olga. "A Neapolitan Christmas Crib from the Loretta Hines Howard Collection." *The Metropolitan Museum of Art Bulletin*, December, 1965. Updated and published separately, 1976.

Rea, Domenico. "L'universo mangereccio del presepe." *Civiltà della campania.* December, 1974.

Spaeth, Eloise. *Two Eighteenth-Century Neapolitan Crèches.* New York, 1961.

Spinosa, Nicola. "Figure presepiali napoletane dal sec. XIV al sec. XVIII." Azienda Autonoma di Cura Soggiorno e Turismo. Naples, October 1970/January, 1971.

————. "The Presepio as Art Work." See *Art of the Presepio: The Neapolitan Crib of the Banco di Napoli Collection.*

Stefanile, Mario. "I presepi d'una volta." *Civiltà della campania.* December, 1974.

Acknowledgments

Even though this book is small in size, it has taken a tremendous number of people to bring it to light. We are so grateful to all who have given so freely of their time and knowledge.

First, we want to thank The Metropolitan Museum of Art for giving us permission to do the book, our second documenting the history of the Loretta Hines Howard collection of eighteenth-century Neapolitan crèche figures and Mrs. Howard's work at the Museum.

Philippe de Montebello has written a most gracious foreword, and Olga Raggio has approved of our reprinting her delightful and scholarly descriptions of the figures in the collection. Also, we greatly appreciate William H. Luers' allowing us to include some of his memories of Christmas in Naples from remarks he made during a recent tree-lighting ceremony.

It was Bradford Kelleher who encouraged us to do the book, and his guidance made it possible.

The series of photographic sittings that had to take place during midnight hours when the Museum was closed was a challenge. Elliott Erwitt was not the least bit daunted, and the result is this book of radiant photographs that show so beautifully the eighteenth-century crèche figures in their Metropolitan Museum setting. For making the arrangements and participating in the process we want to thank Richard Morsches, Linda Sylling, Franz Schmidt, and their able staffs, especially Eric Wrobel, who was the electrician during the sessions, the Museum's security staff, and Douglas Rice and Kristin Reimer, who assist Elliott Erwitt.

While we were compiling information we turned to Johanna Hecht and Edward R. Lubin, who were most generous with their knowledge of the subject. The Museum's Objects Conservation and Textile Conservation departments shared with us their recent findings and techniques for conserving the collection, so that we could include information about the care of the figures. Others at the Museum who gave us direction and support were Lisa Cook Koch, Marilyn Jensen, Robie Rogge, Cristina Del Valle, and Faye Lee.

Enrique Espinoza, the artist who worked with Mrs. Howard from the beginning, told us about the development of the exhibitions; Andrea Selby, Mrs. Howard's granddaughter, shared her experience of working with her grandmother on the installations. Gemma Rossi, who has assisted with the preparation of the exhibition for several years, translated for us a number of Italian publications that gave us important information.

When we met with Paul Gottlieb to discuss the possibility of Harry N. Abrams, Inc., publishing this book, his enthusiasm spurred us on. He turned the project over to a terrific team: Our editor, Margaret L. Kaplan, has done a superb job of working with us on the text and organization of the book. Her associate, Joan Siebert, has kept everything running smoothly. We think Carol Robson has had a special feeling for the material, and her inspired design has turned it into an interesting and informative book of which we are truly proud.

L.H., M.J.P.

About the Authors

Linn Howard assisted her mother, Loretta Howard, with the installation of the tree and crèche at The Metropolitan Museum of Art. Now she and her daughter, Andrea Selby, continue Mrs. Howard's work. She traveled with her mother in Europe on collecting trips, and has her own collection of crèches. Each year she lends some seventy figures and objects to the Museum for the Angel Tree exhibition, and lectures on the crèche across the country. Recently she refurbished and redesigned a major crèche for its owners. Linn Howard studied art and dancing and was a member of the Alwin Nikolais Company. When first married she lived in Nepal; now she summers in Wyoming, where she runs a small dude ranch. The remainder of the year she lives in New York City, where she brought up her three children.

Mary Jane Pool has a special interest in eighteenth-century decorative arts and collects painted Venetian furniture of that period. She is on the board of the Isabel O'Neil Foundation for the Art of the Painted Finish and is a governor of the Decorative Arts Trust. For a number of years she was an editor of *Vogue* magazine, and from 1970 to 1981 she was Editor-in-Chief of *House & Garden*. She now writes and lectures on decoration and design. Her other books include *The Gardens of Venice* and *The Gardens of Florence*.

Elliott Erwitt has been a professional photographer since he was a teenager living in Hollywood. From 1948 his work has appeared, both as illustrations and in advertisements, in virtually every European, Asian, and American popular magazine. He has made numerous documentary films for television, his photographs have been exhibited and are part of collections in major galleries and museums around the world. His books include *Photographs and Anti-Photographs; Son of Bitch; Observations on American Architecture; Recent Developments; Personal Exposures; On the Beach; To the Dogs*. His next book, *Between the Sexes,* is in press. Elliott Erwitt has been a member of Magnum Photos, the international photographers' cooperative, since 1953.

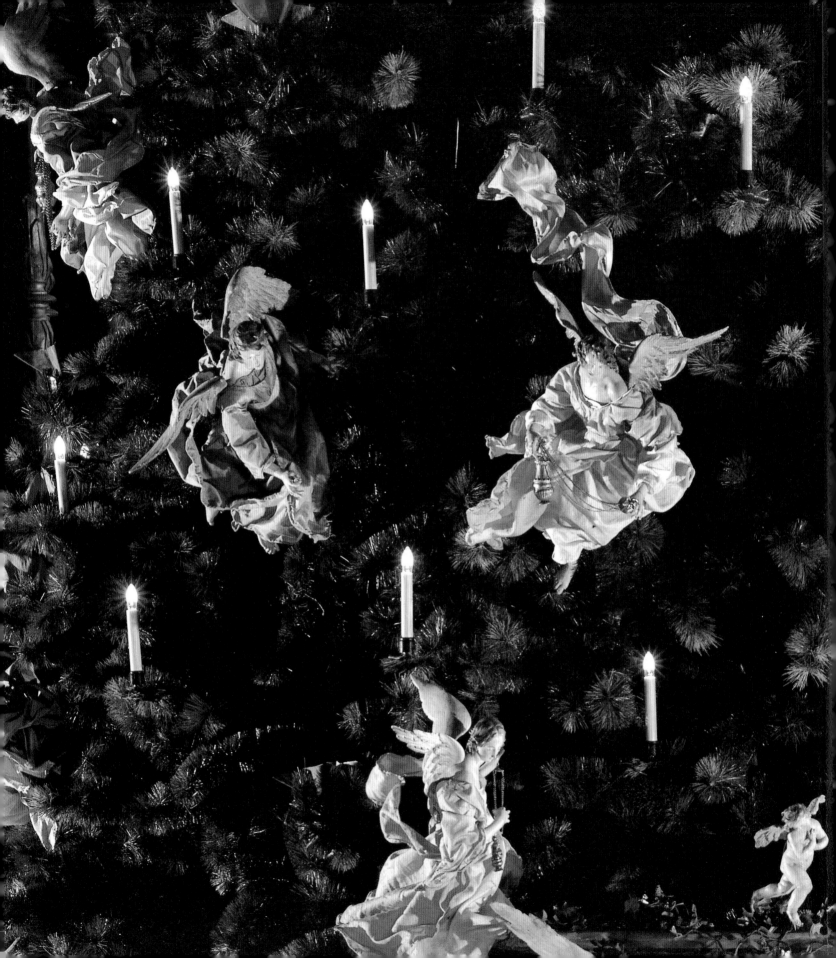